The D_ & Folk Phrases of the Cotswolds

JOHN SMYTH,
RICHARD WEBSTER HUNTLEY
& G. F. NORTHALL

EDITED BY
ALAN SUTTON

AMBERLEY

The Dialect and Folk Phrases of the Cotswolds
first published 2008
by
Amberley Publishing
Cirencester Road
Chalford
Stroud
Gloucestershire
GL6 8PE

British Library Cataloguing in Publication data
To be applied for

ISBN 978-1-84868-018-0

Printed and bound in England by Amberley Publishing

Contents

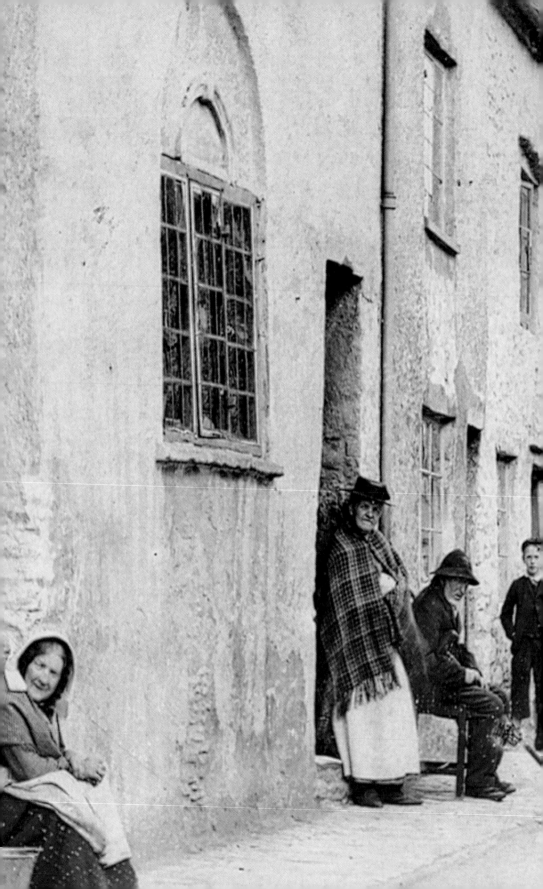

Preface

This book is not the result of my researches and labours, rather the 'cobbling together' of the diligent work of others. In a pejorative sense, it might be referred to as 'hack' writing (or hack compiling). If I can claim any credit, it is merely for thinking of putting these three small collections together and bringing them to a wider audience.

I had long wanted to publish a book on the dialect of my home county, but had never found anyone competent who was willing to take it on. Combined with this wish, I had, over the years, collected copies of the texts reproduced here and it occurred to me that there was merit in putting them together and reproducing the texts as they stood, to let the works of the original authors stand for themselves. We therefore have the works of John Smyth, Richard Webster Huntley and George F. Northall reproduced, more or less, as they were originally published. I say 'more or less' as in some instances I have made a few editorial additions to make their sources more clear. I also have to give credit to other historians whose work I have reproduced, and these include H. P. R. Finberg for his biographical notes on John Smyth.

To leaven the loaf I have added illustrations, and for amusement 20 of these are *Punch* cartoons from the nineteenth century. They may not add to the meaning of the book, but if they result in each corner of the mouth rising slightly they are worth the effort of including in the book.

Alan Sutton,
September 2008

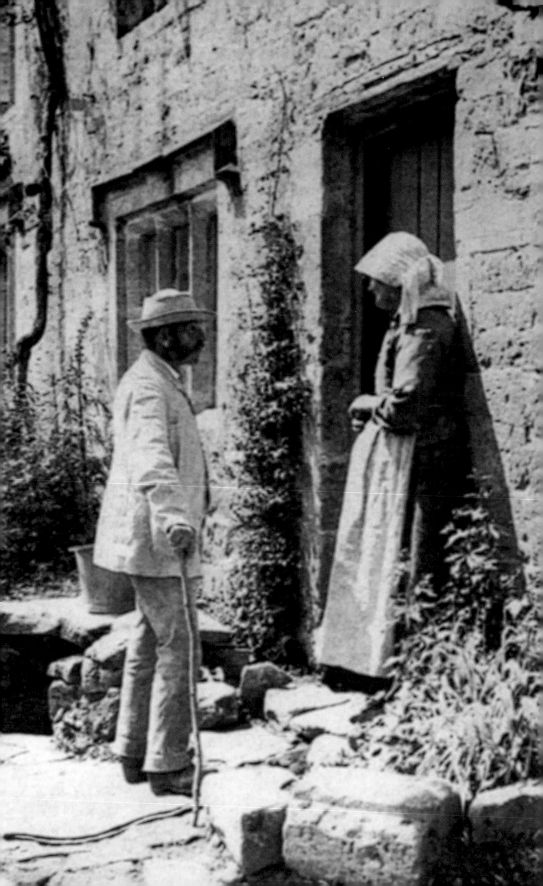

Introduction

My interest in the Cotswold dialect goes back to childhood. My maternal grandmother, Louisa Sutton, née Hancock (1881-1965), had retained a perfect version of the dialect of her youth and, whilst most others around her had mere accents, she still persisted in the use of the pure dialect, seemingly oblivious that she was representing a time-warp. As the grande dame of the family she would hold court and her sisters Nellie and Gertrude, her sister-in-law Olive, and others would congregate in her sitting-room and gossip in their native and local manner. Many years later, after reading Richard Webster Huntley's introduction to *A Glossary of the Cotswold Dialect* (1868) I realised that as a child I had been privileged to listen to something that would never be heard again, and would certainly not be known to my children, grandchildren and future generations. Phrases such as ''er's got a new cær' [pronounced 'kee-ar'] for 'he's got a new car', were typical. The language was rhythmic and deep and much of it went over my head. I now wish I had been able to record it, but in early teens I little realised that this was the end of an era, for as with other youngsters I took life as it was given, reserving my enthusiasm for contemporary happenings such as the Rolling Stones and the Beatles. In my twenties as my interest in history grew I salvaged what I could, but this was after Louisa's generation had virtually passed by. I spent some time with my great-uncle, Arthur, Louisa's youngest sibling, when he was in his nineties (he lived to the age of 101), and from him took much family information, but no sound recordings. In 1997 I did make some recordings, but these were of little use for dialect, for they were made in Pennsylvania, at the home of my father's first cousin, also an Arthur, who had left Dursley for America at the age of eighteen in 1922. His recollections of childhood in the town were unpolluted by later events (for memory does confuse on issues of time) as everything he recalled was obviously before his departure from these shores. For family history these recordings are invaluable, but whatever Cotswold dialect he retained or recalled, was beyond use, being heavily influenced by seventy-five years of living with Americans.

The moral of this is to listen and record what your elders tell you. Much nonsense is inevitable from the sillier elements of family (for we all have them) and much wisdom is to be hoped for from the brightest, but sift and analyse all, and write it down, even if you do not take sound and video recordings. Come to that, even if you <u>do</u> make recordings, still write it down, for the

likelihood of survival of written text for future generations is stronger than the ephemeral nature of digital media where the disk or other storage device may become corrupt. The writings of Smyth, Huntley and Northall in this book are sufficient evidence of this need, for without them our knowledge of the dialect would be far poorer.

Verbal traditions are the bedrock of folklore and phrases, and folk memory in England — even though it is difficult to believe it — goes back to north Germany and to the origins of our Saxon kin. It would not be difficult to find phrases and expressions in Germany that match completely those used amongst us today, and in this sense it is clear that, for the historical record, language and expressions are organic transmutations that occasionally need to be snapshot and stored — in a metaphorical sense — like a scientist using a pipette to drop and seal a sample onto a glass slide.

Before the education reforms of the 1870s and for the fourteen centuries before this, going way back to the Anglo-Saxon migrations, language among the peasantry had been purely verbal with the skill of reading and writing reserved for the elite. It is hardly surprising, therefore, that phrases and their meanings became corrupt, and in reading the texts of our three authors it is evident that they are capturing expressions which occasionally they have difficulty in understanding.

The three writers were all very different and yet all found a great interest in noting what they heard. The following biographical notes provide a basic introduction to each of them.

JOHN SMYTH

The first collection of phrases comes from the pen of John Smyth (1567-1641), steward of the Berkeley family. Rather than re-invent the wheel, there is little point in creating a completely new biographical entry for Smyth when an excellent one was provided in 1957 from the skilled researches of H. P. R. Finberg, and this is reproduced here:

John Smyth entered the service of the Berkeleys at the age of seventeen, first attending Thomas, the young Lord Berkeley, first at Oxford and later at Middle Temple. In 1596 he was appointed steward of the Berkeley household, and in the following year steward of the hundred and liberty of Berkeley. Such duties cannot have been light, and towards the end of his life he could take pride in saying that he had always been a practical farmer: "Fower and 30 yeares a professional ploughman, having all that time eaten much of my bread from the labours of mine own hands." The mass of papers he has left, including such varied items as 'Rules for ye keping my clocke', detailed

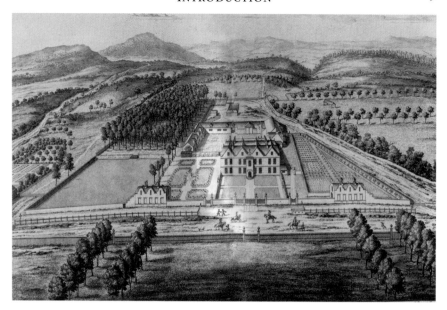

Nibley House, the home of John Smyth, engraved in 1708

notes on sheep, and his impressions of parliament, testify to the painstaking exactitude with which he dealt with everything that crossed his path in a long and exceptionally busy life. Yet he found time for history, and his writings are the product of years of careful research, of "tumblings and tossings of historyes and records, printed and manuscript, in all parts of the kingdom." He could boast that he had "taken in hand, yeare after yeare, most of the Records of the Tower of London," and assure his readers that he had used his sources scrupulously: "I have represented all things truly. I have not adorned, inlarged or hyberlized the matter in lyne or word; my free genius is at enmity with such baseness. I have commended nothing to posterity but what I have found of record, or taken from the venerable manuscripts or the sealed Deeds of men." He shared to the full the intense provincial patriotism of his age, but with him love of county was inseparable from love of the family he served. In the introduction to his most important work he wrote: "The Custome of those who write histories, is to propose in the begynge a modell of the subject they mean to handle: Mine is, of noble men and noble mindes, whom I will not celebrate aboue their merit: stand or stoope they shall unto themselves: Labor I wil through all the monthes 550 yeares to reflect to this family the image of itselfe, in all or the most remarkable actions or accidents, chances and changes, which in the raignes of 24 princes of this English monarchy have fallen upon the descendants thereof." One by one, sketched by his vivid pen, the lords of Berkeley pass before us. As Maurice Berkeley said, writing to him in 1637, "Not one of that Noble Race has escapt: but you haue discouered his Employments,

Suruayed his Lands, Trac'd his Lawsuits, Obserud his Husbandry, nay, watcht his very Recreations: insomuch that Obliuion and Death, which either confound or obliterate all Things, haue unfolded their Black Volumes to your Enquiry; to whome 5 Hundred yeares past seeme but as Yesterday." If this had been nothing more than a panegyric of an illustrious family we should not remember John Smyth with such gratitude today. But *The Lives of the Berkeleys* is more than the history of a family. It is the story of their lands. For Smyth is above all an economic historian, long before 'economic history' was recognized as a distinct branch of study. He wants to know how the fields have achieved their present state, how the changes in tenure and husbandry have come about, how the rents and incomes of the past compare with those of his own day. He writes of enclosures, rents, disafforestation, the marketing of corn and cattle. He uses the accounts of the reeves and bailiffs, not only with the interest of the historian, but with the respect and admiration of the practical man for those who had farmed these acres before him. "It cannot but give us cause to wonder, and to say, Out of our old forefathers' fields we reape the best frutes of our modern understanding."

One book, his description of the hundred of Berkeley, approaches more nearly the conventional historical writing of his day, for here he sets out to give a short account of every manor, tracing its descent from Domesday Book until his own day. Yet even in such a mainly technical and legal record he can still write with warmth and affection, calling the Vale a land blessed above all other by Providence, and declaring with pride, as he lists the proverbs and phrases peculiar to the hundred: "If found in the mouths of any forraigners, we deeme them as leapt over our wall, or as strayd from their proper pasture and dwellinge place."

Finally, although it is not strictly speaking a history, it would be impossible to leave Smyth without mentioning his *Men and Armour*. Military returns were not infrequently demanded by Elizabethan and Stuart governments, but Smyth, with his inveterate love of note-taking, and his thirst for accurate information, transformed the returns for Gloucestershire in 1608 into a piece of most valuable historical evidence. By adding the occupation of every man liable to military service, he left us a contemporary survey of the county in the early seventeenth century which remains unparalleled.

Smyth wrote without literary or artistic pretension, calling his style "playne and home-bred." He claimed little education: "I knowe well how my school studyes, but shrubs and brambles at the best, have been overlonge discontinued." Yet his work has about it a quality of vigour and humanity, for in him antiquarian learning is combined with the practical approach of the man of affairs. He claimed no merit for writing, saying that he wrote because he could not help himself, and that, such was his love of Gloucestershire and of the Berkeleys, "40 yeares delight haled mee along."

Here we leave Finberg's excellent account and look at other aspects of Smyth's career. He was a man of his time and certainly progressive, for in collaboration with Richard Berkeley and several businessmen he invested in an American colony. This 'New World' Berkeley Hundred was a land grant in 1618 from the Virginia Company of London. The grant was to Sir William Throckmorton, Sir George Yeardley, George Thorpe, Richard Berkeley, and John Smyth of Nibley. Smyth was also the historian of the Berkeley group, collecting over 60 documents relating to the settlement of Virginia between 1613 and 1634 which have survived to modern times.

In 1619, the ship *Margaret* of Bristol, England, sailed for Virginia under Captain John Woodleefe and brought 35 settlers to the new Town and Hundred of Berkeley. The proprietors instructed the settlers of "the day of our ships arrival . . . shall be yearly and perpetually kept as a day of Thanksgiving". The *Margaret* landed her passengers at Berkeley Hundred on 4 December 1619. The settlers did indeed celebrate a day of "Thanksgiving", establishing the tradition a year and 17 days before the Pilgrims arrived aboard the *Mayflower* at Plymouth, Massachusetts to establish their Thanksgiving Day in 1620.

The infant colony suffered heavily in a massacre by indians on 22 March 1622, which was Good Friday of that year. Nine people were brutally slain at Berkeley during coordinated attacks at settlements along the James River. The massacre took a heavier toll elsewhere, killing about a third of all the colonists. Jamestown was spared through a timely warning and became the refuge for many survivors who abandoned outlying settlements.

For several years, thereafter, the plantation at Berkeley Hundred lay abandoned, until William Tucker and others got possession of it in 1636, and it became the property of John Bland, a merchant of London, and this ends Smyth's association with the colony, and probably his investment also.

One final comment about John Smyth is his proximity to his contemporary, William Shakespeare (1564-1616). There is evidence (*see* Richard Webster Huntley's comments below) that Shakespeare spent the years 1582-90 living with relations in the hamlet of Woodmancote in Dursley, the largest town in the hundred of Berkeley. A Thomas Shakespeare had married Joan Turner in Dursley in 1577 or 1578. Thomas may have been an elder brother, or an uncle. Dursley is just four miles from Berkeley Castle, and by foot, over the hill, just one-and-a-half miles from Smyth's family home of North Nibley. Given that both youths would have been well-educated, close in age and from similar backgrounds, it seems quite possible that they would have known each other and mixed in the same circles. Certainly they both loved the dialect and phrases of the area, for Smyth was to show his love and enjoyment of it in his 'phrases', and Shakespeare used it as a quarry, for Cotswold dialect is scattered throughout his works.

RICHARD WEBSTER HUNTLEY

It is ironic that we seem to know more about John Smyth who was born in 1567 than we do about Huntley who was more than two centuries closer to our own time.

Richard Webster Huntley (1793-1857) was the eldest son of Revd. Richard Huntley and Anne Webster of Boxwell Court, Gloucestershire. Anne was the daughter of the venerable James Webster, Archdeacon of Gloucester.

In the sixteenth century part of the manor of Boxwell, Gloucestershire belonged to the Huntley family and the other to St. Peter's Abbey, Gloucester. When Queen Elizabeth granted the abbot's half to Sir Walter Raleigh, he sold it to John Huntley. A descendant, Martin Huntley, was a captain in Prince Rupert's Horse and the Prince often visited him. In September 1651 after the battle of Worcester, Charles II escorted by Colonel Lake, was taken to Boxwell and a part of the garden is known as the King's Walk.

The house was built in the fifteenth century, and restored in 1796 with further work carried out during Richard Webster Huntley's time c. 1840.

Richard had at least two brothers, the first was James Webster Huntley (1794-1878), who after commencing his education at Oxford, migrated to Cambridge, and then like Richard himself entered the church. The next brother had a more illustrious life, for Henry Vere Huntley (1796-1864), had a distinguished naval and colonial career, and also wrote numerous books. As a minor footnote to Henry, he was on board the *Northumberland* when she carried Napoleon Bonaparte to St. Helena in 1818. He was knighted in 1841. The present Huntley family at Boxwell is descended from Henry.

Richard Webster Huntley was educated at Oxford and became a fellow of All Souls College. He was ordained in 1817 and in 1829 became vicar of Alberbury, Shropshire, a living which was in the gift of the College. He wasted little time after entering the living, for on 8 July 1830 he married Mary, the eldest daughter of Richard Lyster of Rowton Castle, Shropshire, M.P. for Shropshire, a connection formed while he was performing his clerical duties at Alberbury, for Rowton Castle is only half a mile from the church.

On the death of his father in 1831 he entered the living of Boxwell with Leighterton as rector and appears to have left Alberbury in the hands of his curate, William Thornes and returned to the family estate in Gloucestershire.

Richard and Mary had two sons; the first, Richard Freville Huntley (1833-63) was a barrister and died unmarried. The second son, Henry (1835-63), married Lucy Watts of Sopworth, Wiltshire in March 1861, but had no children before his life was cut short at the age of 28. After this, the estate

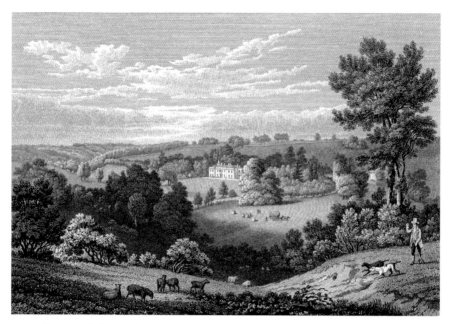

Boxwell Court, the home of Richard Webster Huntley, 1825.

passed to Richard's youngest brother, Sir Henry Huntley.

As for Richard himself we know relatively little. It must be presumed that he was a Tractarian and followed the Oxford Movement with some zeal. The evidence for this is on two counts. Firstly he unsuccessfully opposed the elevation of a contemporary of his at Oxford, Renn Dickson Hampden (1793-1868), to the see of Hereford in 1847. Secondly he was co-editor of a volume of sermons of Sir George Prevost of Stinchcombe, a renowned Tractarian of the time. This volume appeared three years after his own death.

Richard Webster Huntley's other published output is limited. In 1848 he published an odd book, *Chavenage: A tale on the Cotswolds*. This book was in verse and presumably written in memory his late neighbour at Chavenage, John Delafield Phelps, a noted bibliophile with a large library of books and papers relating to Gloucestershire. It may be assumed that the two men had an interest in the history of the County in common and their estates were virtually adjoined, their respective residences separated by only three miles of open countryside. Much of this common interest is evidenced by the last twenty pages of the catalogue of John Delafield Phelps' library, published by John Nicol in London, 1842 and entitled *Collectanea Gloucestriensia*. These pages contain a list of provincialisms and may well have been the catalyst which sent Huntley to work, for many of the words in Phelps appear in Huntley — together with additions. John Delafield Phelps is worth a mention here, as he appears to have been instrumental in Huntley's work.

By background he came from a wealthy clothier family in Dursley whose records go back to the sixteenth century. There is a reference to him in 1775 when he is recorded as being under the guardianship of his mother Esther, so presumably he was born at some point after 1754, probably in the 1760s or early 1770s. He does not appear to have taken any interest in the family business, but was wealthy enough to indulge in his bibliophile passion. He moved from Dursley to Chavenage where he became tenant of the beautiful sixteenth-century house and remained there until his death in 1843, when his book became a catalogue for the sale of his valuable collection. His wealth and interest in books enabled him to become a founder member of a famous club. He was among the eighteen members who first met at dinner at the St. Albans Tavern, on 17 June 1812, forming themselves into the Roxburghe Club — and at once co-opted the next six. The Roxburghe Club was formed by leading bibliophiles at the time the library of the Duke of Roxburghe was auctioned. It took 45 days to sell the entire collection. The first edition of Boccaccio's *Decameron*, printed by Chrisopher Valdarfer of Venice in 1471, was sold to the Marquis of Blandford for £2,260, the highest price ever given for a book at that time. The Roxburghe Club continues to this day, one of the most exclusive societies in the country with the membership limited to 40.

It seems that John Delafield Phelps was a friend and mentor of Huntley and was instrumental in developing Huntley's interest in dialect. It is clear from

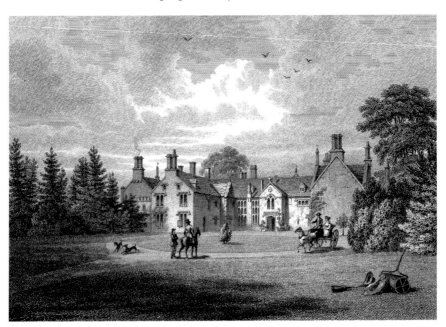

Chavenage House, the home of John Delafield Phelps, 1825.

looking at *Collectanea Gloucestriensia* that this formed the foundation for Huntley's own list of Cotswold vocabulary.

In reading Huntley's introduction, and his perceptive description of the Cotswold dialect, I can hear my grandmother speaking. This struck me very much when I first read Huntley 30 years ago, and even now, in the twenty-first century, with further decades separating me from these childhood memories, the words still ring through.

GEORGE F. NORTHALL

It is unfortunate that we know extremely little about George Northall. He appears to have been born in 1862. In 1881 he is shown as living at 4 Burbury Street Birmingham with his mother aged 42, who had been born in Hartpury, Gloucestershire. For an occupation, the somewhat precocious 19-year-old states himself to be an author. In 1891 he is registered in the census as living at Hatfield Cottage, Short Heath Road, Erdington with his Canadian born wife Priscilla, and their daughter Winifred, aged four. For an occupation, the census simply records 'living on own means'. It seems clear that he came from an ordinary background and lived in a modest environment and yet he had a form of private income that enabled him to indulge himself in his researches. Where this money came from is not known, but was presumably sufficient for him to get by without worry. Whether or not he supplemented his life style by occasional articles is quite possible, but none have been found.

In 1892 Northall found some modest fame with a successful book, *The Popular Rhymes and Nursery Tales of England* published in London by Kegan, Paul, Trench, Trübner & Co. Ltd. This was followed in 1894 by the text included in this present volume, *Folk-phrases of four counties (Glouc., Staff., Warw., Worc.,) Gathered from unpublished mss. and oral tradition.* This was published for the English Dialect Society, by Henry Frowde, Oxford University Press. Northall's final work was *A Warwickshire Word-Book*, also published for the English Dialect Society, by Henry Frowde, 1896. After this nothing more is to be found about him and apart from ongoing references to his works his name fades away. An engraved book plate of his for a valuable book, *Poems on Several Occasions*, by John Philips, 1720, which was recorded at auction, shows that his means were sufficient for him to have a good book collection his hobby subject area, but this apart he disappears from view.

THE ENGLISH DIALECT SOCIETY

The early nineteenth century saw a huge surge of interest in dialect and identity. The Enlightenment of the eighteenth century, with the accompanying intellectual and philosophical developments of that age closely followed by Romantic movement, indirectly led to much searching for identity and national culture. The Napoleonic Wars had meant that the wealthy were unable to travel to France and Italy and as a substitute they took to visiting Scotland, Wales and the Lakes. Here the linguistic challenges of these remote peoples seen during tours 'in search of the Picturesque' were enhanced by a wave of romantic poetry and with long works in verse. *Ossian*, the poems of Robert Burns and later the Lake Poets were all associated with this movement which almost became an industry. This interest turned to a study of the language spoken by the labouring classes. In Gloucestershire John Delafield Phelps and then Richard Webster Huntley had thought they had discovered 'pure Saxon' and for them this was a revelation worth far greater study. Other gentry all over England turned their attention to this study with correspondence occurring in the *Gentleman's Magazine*. Soon books were appearing of folk phrases and folk rhymes. Mixed with this was the interest shown in nursery rhymes and ancient songs. It is hardly surprising that eventually this should be looked on by the academic fraternity, with the idea of regulating the research and focusing it into a scholarly mould.

The Society for the study of Dialect in England was formed in 1873 and dissolved in 1896 when it was considered that its aims had been completed. Its founder was Walter William Skeat (1835-1912), Professor of Anglo-Saxon at Cambridge, who became its secretary and then its director. It published 80 works, mostly glossaries and grammars, and collected material for a dialect dictionary to complement the pronunciation work of A. J. Ellis. In 1886, Skeat launched a fund for such a dictionary, contributing a great deal of money himself to the project. In 1889, Joseph Wright began to edit the first collection for this work and appealed through newspapers and libraries for additional data. Over 600 people read material and collected and checked information. Helped by subscriptions, donations, and accommodation provided by Oxford University Press, Wright began in 1898 to publish in parts what became the English Dialect Dictionary.

The most important person involved in the Society was undoubtedly Joseph Wright who rose from humble origins to become Professor of Comparative linguistics at Oxford University. Born in Yorkshire, the seventh son of a navvy, he started work as a "donkey-boy" (carriage driver) at the age of six, became a "doffer" (remover of full bobbins) in a Yorkshire mill, and never had any

formal schooling. He learnt to read and write at the age of 15, becoming fascinated by languages. He studied in Germany and completed a PhD. on Qualitative and Quantitative Changes of the Indo-Germanic Vowel System in Greek at the University of Heidelberg in 1885. In 1891 he was appointed Deputy Professor and from 1901 to 1925 Professor of Comparative Philology at Oxford.

He specialised in the Germanic languages and wrote a range of introductory grammars for Old English, Middle English, Old High German, Middle High German and Gothic language which were still being revised and reprinted 50 years after his death. He had a strong interest in English Dialect and his greatest achievement was the editing of the six-volume *English Dialect Dictionary*, which he published between 1898 and 1905, initially at his own expense. This remains a definitive work, a snapshot of English dialect speech at the end of the nineteenth century.

Wright was an important early influence on J. R. R. Tolkien, and was one of his tutors at Oxford: studying the Grammar of the Gothic Language with Wright seems to have been a turning-point in Tolkien's life. In the course of editing the Dictionary he corresponded regularly with Thomas Hardy.

Out of the eighty books published by the Society, George Northall was responsible for volumes 73 (*Four Counties*) and 79 (*Warwickshire Word Book*). The *English Dialect Dictionary* is a vast work, worthy of republication in its own right. In this volume we are restricting our interest to the Cotswolds and to the work of the pioneers whose work was used by Wright for the comprehensive dictionary.

THE EDITORIAL METHOD

When, a good few years ago, I first thought of producing this book, it was on the basis of combining everything into one sequence. On reflection it seemed wrong to take other people's work and regurgitate it as my own. In addition there were practical reasons why it would have been difficult editorial task to achieve. I have therefore left the texts much as they are, and in doing so there is inevitable repetition.

With John Smyth's work I have simplified, very slightly, the precise manner in which Sir John Maclean published the transcription for the Bristol and Gloucestershire Archaeological Society in 1885. Apart from this, the text is very much as the original manuscript — with all of its incongruities. Where there is specific need to mention what is happening in the text, an editorial note has been made in italics.

The proverbs and phrases mentioned by Smyth are rather disjointed. He starts off on folio 20 of his manuscript describing phrases as they come to his

mind until he gets to number 21, and then suddenly the numbering ceases, but he continues his listing. I have therefore reproduced in much the same manner as he left his manuscript. Then, on a new folio (23 in his manuscript) he is more precise, and lists exactly 100, with a marginal note at the beginning reading 'Proverbs peculiar to this Hundred'. It may be presumed that these leaves (folios 23 to 29) were written later and then interleaved in his manuscript to ensure they were in the right place, alongside his earlier jottings. He ends on folio 29 by dating the manuscript, December, 1639.

The text from Richard Webster Huntley provided more of a challenge. The editor of this posthumous work, published in 1868, apologises at the beginning saying: *This being a posthumous Work of the Author's, great difficulty has been found in editing it correctly; and the reader will kindly make allowance for any remaining imperfections.* It clearly is imperfect in many respects and the references cited by Huntley leave very much to be desired. I have, where possible, been more precise where the reference has been possible to locate, but like his original editor I have to ask our modern reader to make allowance for the imperfections.

The work commences with a general and very interesting introduction on the Cotswold Dialect, and then continues with a glossary. It is with the glossary that most editorial challenges were to be met.

The final text in the book, the Folk Phrases by George Northall, published in 1894, are more straightforward. Here the only editorial interference is the omission of phrases which are clearly too far removed from the Cotswolds. Therefore anything which is clearly from the Potteries, the Black Country or from Birmingham has been removed, reducing the text by about one quarter from its original extent.

There is little more to say by way of introduction other than to ask the reader to enjoy the contributions from the three gentlemen who had the patience, perspicacity and acuity to record the language of the everyday folk in their Gloucestershire surroundings. If you want more than this book to understand the Cotswold dialect from centuries past, read the works of Mr. William Shakespeare.

Proverbs and Phrases of Speech used in the Hundred of Berkeley

John Smyth

In this hundred of Berkeley are frequently used certaine words proverbs and phrases of speech, which wee hundreders conceive (as we doe of certaine market moneyes,) to bee not only native but confined to the soile bounds and territory thereof; which if found in the mouthes of any forraigners, wee deeme them as leapt over our wall, or as strayed from their proper pasture and dwelling place: And doubtless, in the handsome mouthinge of them, he dialect seemes borne of our owne bodies and natural unto us from the breasts of our nurses: with some fewe of which dishes I will here feast my reader and sport my selfe, vizt.

1. A native hundreder, being asked where hee was borne, answereth where shu'd y bee y bore, but at Berkeley hurns, And there, begis, each was y bore. Or thus, Each was 'geboren at Berkeley hurns.

2. So naturall is the dialect of pronouncinge the letter (y) betweene words endinge and beginning with consonants, that it seemes droppinge from the air into our mouths: As, John y Smyth: John y Cole: Sit y downe: I can y finde it: her has y milkt: come y hither: well y said my Tomy: It's a good y white pott: Each ha kild a ferry vat y hogg: Our sowe does not well y fatt y: hur may y serve for lard y: moder cut y mee some meat: my mal is a good y wench: Watt y ge Tom y some nin y wel y din'd: hur is y gone: I will y goe: Come y my sweet y will y: Th'art my pretty dick y: With thousands the like, accomptinge our selves by such manner of speech to bee true patriots, And true preservers of the honored memory of our fore-fathers, Gower, Chaucer, Lidgate, Robert de Gloucester, and others of those and former ages.

3. The letter (ff) is frequently used for (v). As fewed for viewed: fowe for vowe: fenison for venison: farnish for varnish: and others the like.

4. The letter (v) is frequently used for (f.) as vethers for fethers: vastinge for fastinge: vowlar for fowlar: venne for fenne: a varthinge for a farthing token: vire for fire: vat for fat venison; so powerfull a prerogative of transplantacōn, have wee hundreders over the Alphabet.

5. G is often used for C. As Guckowe for cuckowe; grabs for crabs: A guckold for a Cuckold, and the like.

6. ffor dust wee say, doust: rowsty, for rusty: fousty for fusty, youse for use: and the like.

7. Thicke and thucke, for this and that, rush out with us at every breath. As d'ont thick way; d'ont thuck way: for; doe it on this way: doe it on that way.

8. Putton up, for put it up: putton on thick way: putton on thuck way: setton up, for set it up: cotton of, for cut it of; And many the like.

9. I wou'd it was hild, for I would it were flead, or the skyn of.

10. y w'ood t'wert hild: for, I would thou were hanged.

11. Hur goes too blive for mee: i.e. shee goes too fast for mee.

12. ffippant: i.e. slippery, quicke, nimble.

13. Neighboriden; for neighbourhood in all senses.

14. Wenchen, for wenches or girles.

15. Axen, for ashes.

16. Hur ligs well y bed y rhis morne; i.e. shee sleepes a napp of nyne houres.

17. I can beteeme shee any thinge. i.e. I can deny her nothinge.

18. What? Wil't y pisse a bed. i.e. what will you pisse your bed:

19. Sheeme bene here a numbers while. i.e. mee seemes I have byn here a longe while.

20. Beanes thick yeare are orribly hong'd. i.e. Beanes this yeare are horribly codded.

From this point in the manuscript Smyth continues his examples, but ceases to number them.

Hur is dotherēd. i.e. shee is amazed astonished.

An attery, or thwartover wench. i.e. An angry or crosse natur'd wench.

H'eel take it fery hugey. i.e. hee will take it in evill part. H'eel growe madd y. gaa.i.e. come, let us goe: If you'l goe, gaa. i.e. If you will goe, then come let us goe.

A shard. i.e. a gap or broken place in an hedge.

A loppertage. i.e. A low place where a hedge is trodden downe.

Hembles. i.e. a dead shard or gap, neere to a gate: A frequent word in bylaws at our Courts.

y wud and y cud. i.e. I would doe it if I could.

you speake dwelth. i.e. you talke you know not what.

Each'ill warrant you. i.e. I will be your warrant.

Each ha'nnot wel y din'd. i.e. I have not well dyned.

The letter (u) is frequently used for (i.) As gurdle, for girdle; Threscall for threshold.

Harrouts, for harvest.

To hint. i.e. to end. Hintinge, a word in husbandry.

A wize acre. i.e. a very foole.

Lick many. i.e. like many.

To hite abroad. i.e. To ride abroad on pleasure.

To tett. i.e. to chase. Hee tet my sheepe. i.e. chased them.

To veize, and veizinge. i.e. to chase: chasinge violently up and downe.

Loome, loomer. i. often and oftner. And loomer. i.e. faster.

To loxe. i.e. to convey away privately. A loxer. i.e. A secret purloiner. Loxinge. i.e. private pilferinge.

To vocket, vockater, vockatinge: In like sense as to loxe, a loxer, & loxinge, last mentioned.

The pugg. i.e. the refuse corne left at winnowinge.

Shoon. i. shoes; The naturall ideome of my whole family, my selfe scarce free from the infection.

A penston, a coine or Jamestone.

Thick cole will y no y tind. i. This cole will not burne.

Wee shim all hush at home i.e. wee are all quiet at home.

Meeve. i.e. move. As, meeve them a lich. i.e. move them a like.

Grannam. i.e. granddame, a grandmother. Good gramere. i.e. good grandmother.

Twit. i.e. upbraid.

gait i.e. all in haste; or heddy.

A grible. i.e. A crabstocke to graft upon.

Howe fare fader and moder: when sawe you fader and moder; fader and moder will bee here to morrowe. Altogeather without the pronoun

possessive.

This haye did well y henton. i.e. dry or wither well.

Each am well y fritt. i.e. I am well filled.

Ch'am w'oodly agreezd. i.e. I am wonderfully agreived.

In the familiar difference of the usual words, gay and goe, consisteth halfe the thrift of my husbandries. Gaye is let us goe, when my selfe goes as one of the company: But, goe, is the sendinge of others when my selfe staies behinde.

A goschicken. i.e. a goslin or younge goose.

Ourne, for ours; theirn, for theirs: hurne for hers, and many the like.

A pisse glasse. i.e. an urinal.

A slaterne, i.e. a rude ill bred woman. An haytrell, the like.

An hoytrell, i.e. a loose idle knave.

Hur will bee bedlome anoae. i.e. shee will bee by and by mad.

A Dowd, i.e. An unseemely woman, unhandsome in face and foote.

Dunch, i.e. deafe. Hurts, i.e. bilbaries. Solemburies, i.e. service berries; wized. i.e. wished.

Hee makes noe hoe of it i.e. hee cares not for it.

Hee is an hastis man, i.e. hasty or angry.

Come a downe, i.e. get yee downe. Come y up. i.e. come up. I pray set a downe. i.e. I pray sit downe.

Hite, i.e. Comely. Unhity, i.e. uncomely. You dishite mee, i.e. you shame mee.

Tyd, i.e. wanton. Hee is very tyd, i.e. very wanton. A tyd bit, i.e. a speciall morsel reserved to eat at last.

Each ha fongd to a childe, i.e. I have byn godfather at a childes christninge. Hee did fange to mee, i.e. hee is my godfather.

To fonge, i.e. to receive.

The cowes white, i.e. butter and cheese.

A voulthay i.e. *this is left blank in the manuscript.*

To gale, A galer, The galefishinge; whereof read after, in my descriptcõn of Severne.

These phrases are only a small part of Smyth's Description of the Hundred of Berkeley, and the description he mentions here is not included in this volume.

Wone, twa, three, voure, vive, id est. 1. 2. 3. 4. 5.

Hee n'eer blins, i.e. hee never ceaseth.

Meese, meesy, i.e. mosse, mossy.

Hee wants boot a beame, i.e. Hee wants money to spend: or mony in his purse.

Thuck vire don't y bran, i.e. this fire doth not burne.

It war y gold, that war y gam y; i.e. That was gold w^{ch.} was given mee.

ga'as zo'm of thuck bread, i.e. give mee some of that bread.

Hur ha's well y tund her geer to day. i.e. shee hath applied her booke to day.

Moder, gyn, will not y washen' the dishen'. i.e. Mother, Jone, will not wash the dishes.

Gyn y com y and tyff y the windowes. i.e. Jone, come, and trim up the windowes, (meaninge with flowers.)

Eefee, and eaffee. i. waighty. Eefeer and eefteer. i. waightier. Its eefee corne in hond.

Camplinge, i. brawlinge, chidinge.

Pilsteers. i. pillow beers. But, Claudite jam rivos pueri, sat prata liberunt.

From this point in the manuscript, John Smyth starts a new folio page and makes a marginal note reading: Proverbs peculiar to this hundred.

1. **Hee's** like an Aprill shoure, that wets the stone 9 times in an houre. Hee's like a feather on an hill.—Applyed to an unconstant man.

2. **Hee** is an hughy proud man, hee thinkes himselfe as great as my lord Berkeley.—Our simple ancient honesties knewe not a greater to make comparison by, when this proverbe first arose.

3. **Hee'l** proove, I thinke, a man of Durseley, i.e. A man that will promise much but performe nothinge.—This (now dispersed over England,) tooke roote from one Webb a great Clothier dwellinge in Durseley in the daies of Queen Mary, as also was his father in the time of kinge Henry the viii^{th}; usinge to buy very great quantities of wooll out of most counties of England; At the waighinge wherof, both father and sonne, (the better to drawe on their ends,) would ever promise out of that parcell a gowncloth peticote cloth apron or the like, to the good wife or her daughters, but never paid any thinge: Old Edward Greene vicar of Berkeley, in the first of kinge James, usinge this proverbe in his sermon there, whereat many of Dursley were present, had almost

raised a tumult amongst his auditory, wherof my selfe was one.

4. **Hee** seekes for stubble in a fallowe feild, i.e. hee looseth his labour.
Or, as wee otherwise speake, seekes for a needle in a bottle of hay.

5. **No** pipe noe puddinge: In the like sense as, No penny no pater noster.
Or as, Carmina si placeant, fac nos gaudere palato. Now thou my
penny hast, of the musicke let mee tast.

6. **Hee** that feares every grasse must never pisse in a meadowe. In like
sense as, A faint hart never won a faire lady.

7. **Hee** that's cooled with an Apple, and heated with an egge, Over mee
shall never spread his legg.—A widowe's wanton proverbe.

8. **Neighbor,** w'are sure of faire weather, each ha beheld this morne,
Abergainy hill.—A frequent speach with us of the hilly part of this
hundred; and indeed that little picked hill in Wales over that Towne is
a good Alminake maker; wherof my selfe have often made use in my
husbandry.

9. **Hee** is very good at a white pott.—By white pot, wee westerne men
doe meane a great custard or puddinge baked in a bagg, platter, kettle,
or pan: Notinge heerby, a good trencher man, or great eater.

10. **I must** play Benall with you. A frequent speach when the guest,
immediately after meat, without any stay departeth.

11. **A great** houskeeper is sure of nothinge for his good cheare, save a great
Turd at his gate. I wish this durty proverbe had never prevailed in this
hundred, havinge from thence banished the greater halfe of our ancient
hospitallity.

12. **My** catt is a good moushunt.—An usuall speach when wee husbands
commend the diligence of our wives. Wee hundreders maintaininge as
an orthodox position, That hee that somtimes flattereth not his wife
cannot alwaies please her.

13. **Quicklye prickes** the tree, that a sharpe thorne will bee.—In like sence,
as elsewhere.—Soone crookes the tree, that a good cambrell will bee.
Contrary to that wicked one—A younge saint an old Devill.

14. **Day** may bee discerned at a little hole.—Diversly and not unaptly
applied.

15. **The** gray mare is the better horse.—meaninge, that the most master
goeth breechlesse: i.e. when the silly husband must aske his wife,
whether it shall bee a bargaine or not.

16. **Money** is noe foole, if a wise man have it in keepinge.—Alludinge
to the old common sayinge,—That a foole and his money are soone
parted.

17. **When** wheat lies longe in bed, it riseth with an heavy head. When wheat is sowne in October or November, and by reason of an heavy furrowe cast upon it, or other accident of nyppinge wether, shewes not above ground till December or January, Our plowmen say It will at harvest have the greater eare; But, (by the leave of my fellow ploughmen and their proverbe,) I thinke both they and my selfe bury neere halfe the seed wee sowe in that manner, that never riseth.

18. **Dip** not thy finger in the morter, nor seeke thy penny in the water.— Lord Coke, cheife Justice, in the yeare 1613, brought this into that hundred at the maryage of the lady Theophila Berkeley to Sir Robert his eldest sonne, which since is growne frequent. A prudent dehortation from buildings and water-workes. ffor my follies in both, I may justly bee indited.

19. **Hee's** like the master Bee that leades forth the swarme.—Alludinge to the prime man of a parish, to whose will all the rest agree.

20. **Hee** mends like sowre ale in sommer. i.e. Hee growes from nought to worse.

21. **Hee** hath offered his candle to the divell.—This (now common) thus arose; Old ffillimore of Cam, goinge in Anno 1584, to Psent Sr Tho. Throgm: of Tortworth with a suger lofe, met by the way with his neighbor S. M: who demanded whither and upon what busines hee was goinge, answered, **To offer my candle to the Divill**: which cominge to the eares of Sr Tho: At the next muster hee sent two of ffillimores sonnes soldiers into the Low countries, where the one was slayne and the other at a deere rate redeemed his returne.

22. **Be-gis**, be-gis, it's but a mans fancy.—A frequent speach which thus arose: William Bower of Hurst ffarme, had each second yeare one or more of his maidservants with childe, whom, with such portions as hee bestowed upon them, hee maryed either to his menservants, (perhaps also sharers with him,) or to his neighbors sonnes of meaner ranke: Some yeares past, it was demaunded of A: Cl: why hee beinge of an estate in wealth well able to live, would marry one of Bowers double whores, (for by her hee had had two bastards,) wherto A. Cl: soberly replyed, Begys, Begys, its but a mans fancy, Its but a mans fancy: meaninge, &c. take which of the constructions you please; In both senses it's common with us hundreders.

23. **Gett** him a wife, get him a wife. W. Quinten of Hill havinge a pestilent angry and unquiet wife, much more insultinge over his milde nature then Zantippe over Socrates, was oft enforced to shelter himselfe from those stormes, to keepe his chamber: whence, hearinge his neighbors complayninge of the unrulines of their towne bull, whom noe mounds would keepe out from spoilinge of their corne feilds, the bull then

bellowing before them, and they then in chasinge him towards the common pound; peepinge out of his chamber windowe, cryed to them; **Neighbors, Neighbors, gett him a wife, gett him a Wife**; meaninge, That by that meanes hee would bee made quiett and tamed as himselfe was: from whence this proverbe (nowe frequent) first arose.

24. **If** once againe I were Jacke Tomson or John Tomson, I would never after bee good man Tomson while I lived: Hence this, thus: This Jacke Tomson soe called till sixteene, and after John Tomson till hee maryed at 24, was the only jovyall and frolicke younge man at merry meetings and Maypoles in all Beverston, where hee dwelled: After his maryage, (humors at home not well settlinge betweene him and his wife,) hee lost his mirth and began to droope, which one of his neighbors often observinge, demanded upon a fit opportunity, the cause of his bad cheare and heavy lookes; wherto, hee sighing gave this answere: Ah neighbor, if once againe I were either Jacke Tompson or John Tomson, I would never bee goodman Tomson while I lived: This story I derived from William Bower the elder, the old Bayle of this hundred, upon whose kinsman the instance was; And from whome his owne case dissented but little.

25. **Hee** drew it as blith as a Robin reddocke: vizt, As a robin redbrest.

26. **Ch'am** woodly agreezd. Vzt, I am wonderfully greived.

27. **When** Westridge wood is motley, then its time to sowe barley.

28. **Hee's** well served, for hee hath oft made orts of better hay; Orts is the coarse butt end of hay which beasts leave in eatinge of their fodder: This proverbe is applyed to man or woman who resusinge many good offers in maryage, either in greatnes of portion or comlines of person, At last it makes choice of much lesse or worse.

29. Hee hath sold a beane and bought a peaze; $\Big\}$ Reproaches
 Hee hath sould a pound and bought a penny; to an unthrifty
 Hee hath sold Bristoll and bought Bedminster; man.

30. **Beware** Clubs are trumps; Or clubs will prove trumps. A caution for the maids to bee gone for their Mistresses anger hath armed her with a cudgell: Or, to the silly husband to bee packinge, for his wife draweth towards her altitude.

31. **Hee's** a true chipp of the old blocke. Like sonne like father.

32. **All** the maids in Wanswell may dance in an egg shell. I hold this a lying proverbe at this day, it slandereth some of my kindred that dwell there.

33. **Hee** has met with an hard Winter. Alludinge to one recovered from a pinchinge sicknes: or to a beast cast down with hardnes of fare.

34. **Simondsall sauce**, usuall To note a guest bringinge an hungry appetite

to our table: Or when a man eates little, to say hee wants some of Simondsall sauce: The farme of Simondsall stands on the highest place and purest aire of all that country: If any scituacōn could promise longe and healthy daies I would thence expect it: provided I have a good woodpile for winter.

35. **Simondsall newes.** The clothiers horscarriers and wainmen of this hundred who weekely frequent London, knowinge by ancient custome, That the first question, (after welcome home from London,) is What newes at London; Doe usually gull us with feigned inventions, devised by them upon those downes; which wee either then suspectinge upon the report, or after findinge false, wee cry out, Simondsall newes. A generall speach betweene each coblers teeth.

36. **Hee** is as milde as an hornett. Meaninge a very waspe in tongue or trade; This proverbe I have from my wife, a true Cowleian, and naturall bred hundredor; A proverbe as frequent with her, as chidinge with her maides.

37. **Poorly** sitt, ritchly warme; when on an high chaire wee sit before the fire the legs are only warmed: but sittinge on a poore lowe stoole, then thighes belly breast & bosome face & head take benefitt & are warmed. Howbeit wee hundredors somtimes metaphorize this proverbe into a prudent counsell, directinge our worldly affaires.

38. **ffaire** fall nothinge once a yeare. It needs no comment.

39. **I'le** make abb or warp of it. If not one thinge yet another.

40. **In** little medlinge is much ease. Of much medlinge, comes no sound sleepinge.

41. **An** head that's white to mayds brings noe delight: or An head that's gray serves not for maydens play: In which state my constitucōn now stands.

42. **When** the daies begin to lengthen the cold begins to strengthen.— meaninge the coldest part of Winter is after the winter Solstice. Alludinge also to the rule of husbandry: That at Candlemas a provident husbandman should have halfe his fodder, and all his corne remaininge.

43. **All** is well save that the worst peece is in the midst. Noe speach more true, when the taylor first puts on our wives new gownes.

44. **A** man may love his house well though hee ride not upon the ridge: Or, Love well his cowe though hee kisse her not.

45. **As** nimble as a blinde cat in a barne.

46. **I** w'ud I c'ud see't, ka' blind Hugh. for I would I could see it.

47. **Lide** pilles the hide: meaninge that March (called by us lide) pinches the poare man's beast.

48. **Two** hungry meales makes the third a glutton. In like sence as, Hungry dogs eat durty puddings.

49. **If** thou lov'st mee at the hart, thou'lt not loose mee for a fart. Often varied into divers applicacõns.

50. **When** the crow begins to build then sheepe begin to yeald: meaninge, that the fall of rotten sheepe is principally in ffebruary or March, wherin that bird gathereth sticks to make her nest: Alludinge to that other proverb, Michaelmas rott comes short of the pott: intimatinge, that those sheepe which by wett somers hony dewes, or like causes of rott, which when commonly comes in August or September, Rottinge at Michaelmas, dye in Lent after, when that season of the yeare permitted not the poore husbandman to eat them.

51. **Smoke** will to the smicker: meaninge, If many gossips sit against a smokey chimney the smoke will bend to the fairest; A proverbe which doth advantage a merry gossip to twitt the foule slutt her neighbour.

52. **A misty** morne in th'old o'th moone doth alwaies bringe a faire post-noone. An hilly proverbe about Simondsall.

53. **The** more beanes the fewer for a penny. Meaninge, When beanes prove best wheat and barley proove worst, wherby the price of pulse is raised.

54. **When** thou dost drinke beware the tost, for therein lyes the danger most.

55. **My** milke is in the Cowes horne, now the zunne is 'ryv'd at Capricorne: meaninge, when the dayes are at shortest, the cowe commonly then fed with strawe and neere the calvinge, gives little or no milke.

56. **Bones** bringe meat to towne: meaninge, Difficult and hard things are not altogether to bee rejected, or things of small consequence.

57. **A poare** mans tale may now bee heard: vizt., When none speakes the meanest may.

58. **Store** is noe fore; Plenty never rings it's master by the eare.

59. **In** descripcõn of our choicest morsells, wee say; The backe of an hearinge, the poll of a tench, The side of a salmon, the belly of a wench.

60. **Kitch** doth proove the man who hath the hand, To bury wives, and t'have his sheepe to stand.

61. **A sowe** doth sooner then a cowe, bringe an oxe to the plowe: meaninge, more profit doth arise to the husbandman by a sowe then a cowe.

62. **As** bawdy as a butcher: meaninge, that filthines stickes to his conditions, as visibly as grease to the butchers apron.

63. **Hee** that will thrive must rise at five: But hee that hath thriven may lye till seaven.

64. **Hee** that smells the first favour, is the faults first father. This proverbe admits many applicacõns: The homlyest is, That hee first smels the fart that lett it.

65. **Hee** is tainted with an evill guise, Loth to bed, and lother to rise.

66. **Hee** that worst may, must hold the candle. Or, the weakest goes to the wall.

67. **If** two ride upon an horse one must sit behinde; meaninge, That in each contention one must take the soile.

68. **Bee** the counsell better, bee it worse, ffollow him, that beares the purse.

69. **Many** esteeme more of the broth, then of the meat sod therein. Diversly applied.

70. **The** Crowe bids you good morrow. A phrase wherby wee figuratively call a man a knave.

71. **Barley** makes the heape, but wheat the cheape: Meaninge, that a good wheat yeare pulles downe the price of its selfe and of all other graines, which noe other graine doth.

72. **Hee** bites the eare, yet seemes to cry for feare: meaninge, hee doth the wronge yet first complaines.

73. **Neerest** to the well furthest from the water. Like, neerest to the church furthest from God.

74. **Hee** never hath a bad day that hath a good night: not much unlike, Hee never hath a bad lease that hath a good landlord.

75. **Hee** hath eaten his rost meat first: diversly applyed.

76. **Nocke** anew, nocke anew. i.e. Try againe.

77. **Boad** a bagg, and bearn'. i.e. An ill hap falles where it is feared.

78. **Need** and night make the lame to trott.

79. **The** owners foot doth fatt the soile: Or the masters eye doth feed the horse.

80. **The** cup and cover will hold togeather: Birds of a feather will flocke togeather; Like will like; The Dyvell likes the collier.

81. **Faire** is the weather where cup and cover doe hold together: vizt, where husband and wife agree.

82. **Things** ne'ere goe ill where Jacke and Gill pisse in one quill.

83. **A Woman**, spaniell, and a walnut tree,
 The more they are beaten, better they bee.

84. **Much** smoke little fire; much adoe about nothinge.

85. **Hee** that wreakes himselfe at every wronge,
 Shall never singe the ritch mans songe.

86. **A style** toward, and a wife forward, are uneasy companions.

87. **As** the good man saies, so it should bee,
 But as the good wife saies, soe it must bee.

88. **As** proud as an Ape of a whip; vz. not proud at all; rather in dislike of ye. thinge.

89. **On** St· Valentines day cast beanes in clay, But on St· Chad sowe good and badd.—So that wee hundredors lymit the seed time of that lenten crop between the 14th· of ffebruary and the second of March.

90. **As** proud as a dog in a dublett. i.e. very proud.

91. **Patch** by patch is yeomanly; but patch upon patch is beggerly.

92. **Winter** never dies in her dams belly. Our climate is sure of frosts or snowes first or last.

93. **Botch** and sit, build and flit. I beshrew this proverbe, wherby the tenant is kept from a comly repairinge of his house, for doubt of havinge it taken in revertion over his head.

94. **Its** merry in the hall when beards wagg all. i.e. when men are eatinge, and women dancinge.

95. **The** mice will play when the catt is away. i.e. Servants will loyter when the master is absent: This my experience in my longe abodes abroad, all my life longe, hath prooved too true for my profitt.

96. **Lill** for loll: Id est, one for another: As good as hee brought:

97. **When** Wotton hill doth weare a cap, Let Horton towne beware of that. i.e. That foggy mist commonly turnes that way into raine.

98. **Better** a bit then noe bread. i.e. Somthinge is better then nothinge. Nothinge hath noe favour.

99. **Many** seames many beanes. An husbandly proverbe checkinge great and broad furrowes, too frequent with our hynde servants.

100. **Beware** the fox in a fearne bush. i.e. Old fearne of like colour keepes often the fox unperceived. Hypocrisy often clokes a knave.

I have now ended what I intended in generall, in sport or earnest, in the description of this hundred.

December, 1639

And here we leave John Smyth, a pioneer in his historical researches, leaving a vast treasure trove for the modern-day researcher. His sayings and proverbs were clearly the lighter end of his writings, and he clearly gained personal pleasure from jotting them down, but in these, his informal moments, he has left a record of great importance.

Remarks
on the
Cotswold Dialect

Richard Webster Huntley

Dialect is one of the best evidences of the origin and descent of the people who use it; and, whenever we can trace it to its roots, we seem to fix also the country which supplied the first inhabitants of the region where it is spoken. Bringing their language with them from the cradle whence they emigrated, every people brings also its customs, laws, and superstitions: so that a knowledge of dialect points also towards a knowledge of feelings, seated (in many cases) very deeply, and of prejudices which sway the mind with much power; and thus we gain an insight into the genius and probable conduct of any particular races among mankind.

Another reason, which at this present time renders dialects more worthy of remembrance, is the universal presence of the village schoolmaster. This personage usually considers that he places himself on the right point of elevation above his pupils, in proportion as he distinguishes his speech by classical or semi-classical expressions; while the pastor of the parish, trained in the schools still more deeply, is very commonly unable to speak in a language fully "understood of the people," and is a stranger to the vernacular tongue of those over whom he is set so that he is daily giving an example which may bring in a Latinized slip-slop. In addition to this, our commercial pursuits are continually introducing American solecisms and vulgarisms. Each of these sources of change threaten deterioration. Many homely but powerful and manly words in our mother tongue appear to totter on the verge of oblivion. As long, however, as we can keep sacred our inestimable translation of the Word of God, to which let us add also our Prayer-book, together with that most wonderful production of the mind of man, the works of Shakespeare, we may hope that we possess sheet-anchors, which will keep us from drifting very far into insignificance or vulgarity, and may trust that the strength of the British tongue may not be lost among the nations.

It has, moreover, been well observed that a knowledge of dialects is very necessary to the formation of an exact dictionary of our language. Many words

are in common use only among our labouring classes, and accounted therefore vulgar, which are in fact nothing less than ancient terms, usually possessing much roundness, pathos, or power; and, what is more, found in frequent use with our best writers of the Elizabethan period. The works of Shakespeare abound in examples of the Cotswold dialect, which indeed is to be expected, as his connexions and early life are to be found in the districts where it is entirely spoken; and if, as has been thought, he spent some part of his younger days in concealment in the neighbourhood of Dursley, he could not have been better placed to mature, in all its richness, any early knowledge which he might have gained of our words and expressions. This, however, is certain, that the terms and phrases in common use in the Cotswold dialect are very constantly found in his dialogue; they add much strength and feeling to it; and his obscurities, in many cases, have been only satisfactorily elucidated by the commentators who have been best acquainted with the dialect in question.

The Cotswold dialect is remarkable for a change of letters in many words; for the addition or omission of letters; for frequent and usually harsh contractions and unusual idioms, with a copious use of pure Saxon words now obsolete, or nearly so. If these words were merely vulgar introductions, like the pert and ever-changing slang of the London population, we should look upon them as undeserving of notice; but as they are still almost all to be drawn

"NONE BUT THE BRAVE DESERVE THE FARE." The Rector's wife (at school feast, to one of the boys, who had been doing very "good business"). "What's the matter, Noggins? Don't you feel well?" Noggins. "No, m'm,-but-i'll hev-to be wuss, m'm-afore I give in!"

from undoubted and legitimate roots, as they are found in use in the works of ancient and eminent authors, and as they are in themselves so numerous as to render the dialect hard to be understood by those not acquainted with them, they become worthy of explanation: and then they bring proof of the strength and manliness of the ancient English tongue, and they will generally compel us to acknowledge, that while our modern speech may possibly have gained in elegance and exactness from the Latin or Greek, it has lost, on the other hand, impressiveness and power.

We believe that the roots chiefly discoverable in this dialect will be the Dutch, Saxon, and Scandinavian; bearing evidence of the Belgic, Saxon, and Danish invasions, which have visited the Cotswold region. Occasionally, a Welsh or Gaelic root shows itself, and is probably a lingering word of the old aboriginal British inhabitants, who were subsequently displaced by German or Northern irruptions. One or two words seem to be derived from the Sanscrit, which may have been obtained from our German relations; one word from the Hebrew may have been left among us when the Celtic tribes were driven into Wales.

To these old words, now nearly lost in modern conversation, is to be added a corrupted use of the Saxon grammar; whence modes of expression are produced which at first sight are obscure, as having never obtained admission in the colloquy of the better informed, and as being in themselves ungrammatical.

We presume that the most ancient work now extant written in the Cotswold dialect is the "Chronicle of Robert of Gloucester," who lived, according to his own statement, at the time of the battle of Evesham, i.e. August 4, 1265. This historian and versifier may be said to use altogether the Cotswold tongue, and his language is that which is still faithfully spoken by all the unlettered ploughboys in the more retired villages of the Gloucestershire hill-country. This dialect extends along the Cotswold, or oolitic, range, till we have passed through Northamptonshire; and it spreads over Wilts, Dorsetshire, northern Somersetshire, and probably the western parts of Hampshire. In Oxfordshire the University has considerably weakened the language by an infusion of Latinisms; and in Berkshire it has suffered still more by London slang and Cockneyisms.

In noticing the change of letters observable in the vernacular tongue on the Cotswolds, we will begin at the beginning.

A. This vowel, in the first place, frequently receives reduplication; we may instance "A-ater," for "After." The next change which this letter admits is into the dipthong Æ as in "Æle" for "Ale;" in these cases it is common to have the letter "Y" placed before the dipthong, as "Yæle;" sometimes so rapidly pronounced as to sound like the word "Yell," an outcry. "Lærk" stands for "Lark," the bird; with similar instances of alteration, which generally are preservations of the Saxon pronunciation. Next, we find the letter changed into "ai," as in "Make—Maike," "Care—Caire;"

and where the "ai" is the legitimate mode of spelling, there it obtains a great elongation of sound, as "Fair" becomes "Fai-er," "Lair" (of a beast) "Lai-er"; for this use we have found no authority. Next, the letter "a" frequently becomes "o," as in "Hand—Hond," "Land—Lond," "Stand—Stond," "Man—Mon;" the whole of which are pure Saxon, and are found in constant use by Robert of Gloucester. Finally, the dipthong "au" frequently becomes "āā" as in "Daughter—Dāāter," which is unadulterated Danish; "Draught—Drāāt,"with many other instances. This is also the case where the letter "a" has properly the sound of this dipthong, as in "Call—Cāāl," "Fall—Vāāl," "Wall—Wāāl," and suchlike words; to these we will add "Law," which is pronounced "Lāā," agreeing with the Saxon "Lah."

B is, as we might expect, sometimes interchanged with P, as in the name of the plant "Privet," often called "Brivet;" it is also sometimes, though not frequently, used for W, as "Beth-wind," for "With-wind," "Edbin" for "Edwin;" "Bill" for "Will," is common everywhere.

C is changed, occasionally, into G, as for "Crab—Grab," "Crisp—Grisp," "Christian—Gristin;" "Guckoo" for "Cuckoo" is universal, but this, like the Scotch "Gowk," arises, possibly, from a misapprehension of the note of the bird. In the word "Yonder," C usurps the place of Y, and the term becomes "Conder;" this, however, may only be a change from G into C, as the Saxon word is "Geonda."

E is frequently changed into the dipthong Æ, as "Beech—Bæch," "Sleep—Slæp," "Feel—Væl," Saxon "Fællan," with many other instances. It also becomes A short, as "Peg—Pag," "Keg—Kag," "Their—Thair." Next, by abbreviation, it becomes I, as "Creep—Crip," Saxon, "Crypan," "Steep—Stipe," Suio-Gothic, "Steypa." When it is in composition with A, it seems to divide the syllable in which it so stands, as "Beat" becomes "Bē-āt," "Death—Dē-āth," Earth—Yē-ārth," "Tart Tē-ārt" as applied to the smart of a sore place, or the sharp taste of an acid, as well as when the substantive, a fruit-pie, is intended. "Am" becomes "Ye-am;" but here we may observe, that this may be the Saxon "Eagm," as "Ye-arth" may also come from the Danish "Jord."

F, as is usual in all languages, often interchanges with V; thus "Fig" becomes "Veg," "Feed—Veed," Dutch "Veedan;" "Fill—Vill," Saxon "Villan;" "For—Vor," Dutch "Ver." This appears to have been our use from the earliest periods. Robert of Gloucester gives us "Vut" for "Foot," "Vant" for "Font," "Ver" for "For," "Vall" for "Fall," with innumerable other instances; all faithfully followed on the Cotswold range.

G interchanges with Y. This is a custom drawn immediately from the Saxon, in which language these two letters sometimes appear to be used almost indifferently. Thus "Angel" is often pronounced "Anyel," "Angelic—Anyelic," or even "Anyely," where the Saxon termination "lic" or "like" sinks, as in other cases, into the modern "ly."

H is chiefly remarkable for its wrong position. It is struck off, or put in, without any authority at the discretion, or rather indiscretion, of the speaker; only custom seems to have arranged unhappily, that it should appear where it ought to be absent, and should be wanting where it ought to be present. "Why 'op ye so, ye 'igh 'ills?" has been heard from "the priest's lip keeping knowledge." "'Ope" stands for "Hope," "'Unt" for "Hunt," "Edge" for "Hedge," "Helm" for "Elm," "Hasp" or "Haspen," for "Asp" or "Aspen," "Hexcellent" for "Excellent," "Hegg" for "Egg," with as many other instances as there may be opportunities for error. This also seems to have been an ancient practice, as Robert of Gloucester is constantly found labouring under this uncertainty; indeed, it would be difficult to understand him at all unless this regularity in mistake on his part is always borne in mind. As an example, we will give his word "Atom." This is more than a dissyllable, it is two words, being "At om," contracted from "At ome," and by supplying the H struck off, we have the sense "At home." But we must not forget that some of these changes are merely the old Saxon preserved in its purity: as in the example above, "'Unt for Hunt," we read "Geuntod of Angel-cynne." See "*Saxon Chronicle*," Ingram, Appendix, p. 381.

I interchanges with E, as "Drink" becomes "Drenk," "Bring—Breng," both being the Saxon pronunciation; as also "Sink—Zenk," "String— Streng," "Sting—Steng," "Sing—Zeng;" the instances are indeed perpetual, and may be generally held to be derived from the Saxon. "Drive" is always "Dreeve." "Thrive," however, never loses the I; but, as nature abhors a vacuum, the word is ordained to step into the space which is vacated by the word "Dreeve," and it usually becomes "Drive."

M becomes N in the word "Empty," which is pronounced "Enty," and is the only change of the kind which we have noticed.

O commonly usurps the place of A, as we have observed under that letter. It is, moreover, often changed into "Au," as "Snow" is pronounced "Snau," "Blow blau," "Mow Mau;" these sounds have their origin in the Saxon tongue. Sometimes is made into āā, as in "Croft," which is spoken "Crāāt" very frequently, "Moth—Māāt", Saxon Matha. Lastly, in some words this vowel changes into A, as in "North," which is frequently pronounced "Narth."

P, as might be expected, in some cases becomes B, which we have noticed under that letter.

R is very often misplaced, as "Cruds" for "Curds."

S in like manner suffers from dislocations, thus "Hasp" is "Haps," "Clasp—Claps," "Wasp—Waps," with other examples. This letter is also very frequently made Z, in which we agree with the Dutch, as in "Sea," "Zee;" and this practice may be as old as the Belgic invasion of these parts, which is mentioned by Caesar as having taken place before his age.

T and Th are often changed into D when before the letter R Thus "Through"

Curate, after weeks of serious reading and conversation with Gaffer Stokes without much apparent result, is at last rewarded by a look of rapt exaltation on the Gaffer's face. Gaffer Stokes. "A-men! That's the first waps I see this year!"

becomes "Dru," "Three—Dree," "Trill," and "Thrill—Drill," "Thrush" and "Throstle," "Drush" and "Drostle," "Track" becomes "Drack," "Tree—Dree," "Trash—Drash," "Throw—Drow," which also may generally be held to be Dutch usage. "Th" is always pronounced as in the word "This," not as in "Thistle," that is, it always has a slight sound of the D before it.

U, sounded hard, takes the place of the double O, as "Brook," which is pronounced "Bruck," Saxon, Broc, "Book—Buck," Saxon, Boc, "Look—Luck" Saxon, Loc, with other instances.

W is often seated so strangely, and sometimes inserted so capriciously into the interior of words, that, if it is held to be the di-gamma, it might tend to justify Dr. Bentley in thrusting it, for the versé sake whenever he wants it, into the middle of Homer's words. We will notice it first as improperly commencing words; thus, "Oats" becomes "Woats," by abbreviation "Wuts," "Oaks—Woaks—Wuks," "Home—Whome—Whum; in the interior of words we have "Go—Gwoa," "Going—Gwain," "Stone—Stwon," "Bone—Bwone," "Kindle—Kwindle," "Such—Zwitch," with many other instances. If, however, this letter usurps positions to which it is not entitled, so it loses also in some cases its natural rights, as "Wool—Woollen" is often made "Ool—Oollen," "Worsted—Oosted," "Wolf—Oolf," "Wood—Ood," and thence sometimes "Hood," with such like instances of deposition. This

elision seems to have a Danish character. Caprice alone appears to have dictated the erroneous insertions of the letter.

Y claims, and obtains also, a very leading position in the same arbitrary manner. Thus "Ale" is "Ye-ale," "Health—Y-ealth," "Earth—Y-earth," "Am—Ye-am," "Head—Yead." It suffers, however, total defeat in "Yes," which is always either "Iss" or "Eece," according to the leisure of the speaker.

Z, as we have said, is in constant use for S.

We will now notice some of the contractions in speech which are in constant use on the Cotswolds. "At," "At-unt," represent, "Thou art," and "Thou art not" Fielding, as he places Squire Western's residence in the north of Somersetshire, very properly bestows on him a considerable dash of the dialect in question, "I' ool ha' zativsaction o' thee," answered the squire, "soa doff thy cloathes, at-unt half a man," etc. *History of Tom Jones a Foundling*, book VI., ch. 9.

In the same manner "Cat?" and "Cast?" stand for "Canst thou?" and "Cass-nt," for "Canst thou not?"

"D'wye" imploringly, represents, "Do ye;" as "D'wunty," "Do ye not."

"Thee bist," is, "Thou beest," "You are."

"Gee-wult?" "Go, will you?" is a term addressed to horses, when they are to move from the driver; as "K'-mae-thee," "Come hither," is the term to make them draw nearer.

"Oos-nt,-oostt?" is, "You would not, would you?"

"St-dzign?" is the contraction of "Do you design?" i.e., "intend." "St-gwain?" "Are you going?" "St-hire?" is "Do you hear?" "St-knaw?" "Do you know?" In these and similar instances the "St" is the termination of "Dost" or "Beest," as the case may be, and is barely sounded. "Hae" is, "Have," "Shat" and "Shat-unt," are, "You shall," and "You shall not." Squire Western promises Blifil, "I tell thee, shat ha' her to-morrow morning." *History of Tom Jones a Foundling*, book VII., ch. 6.

"Te-unt" means, "It is not." "Why-s-'nt?" is contracted from "Why-oos-nt?" "Why will you not?" as "Coos-nt" is, "Could you not?"

"'S-like I shall" is, "It is likely I shall." "Said'st thine?" "Didst thou say it was thine?" "Nar-on" is, "Never a one"—none. "St-Thenk?" is, "Do you think?" "'E'en as 'twur" is, "Even as it were." "Med" is, "He might"—"Med, med'nt ur?" represents, "He might, might he not?"

"Mizzomar" for "Midsummer" we should not have introduced, had it not been that we find this contraction in Robert of Gloucester, which seems to give a great antiquity to these abbreviations.

Among variations from Mr. Lindley Murray's *English Grammar*, we will first

remark that the use of the pronoun "He" is nearly universal. The feminine "She" is rarely admitted, and the neuter "It" is equally excluded. "She," when brought into use, is mostly compelled to submit to an appearance in the accusative case, "Her"— as, by way of example, "Her y-'ent sa' desperd bad a' 'ooman as I've a knawed," would be very good English on the Cotswold range. It is, however, very questionable, when the word "He" is used for "She," whether we have anything more than the Saxon "Heo," which is our "She." The dominion, however, of "He" over "It" is very undoubted, as anything inanimate in itself is always "He" for instance, a Spade, a Shoe, a Pond, a Gate, a Road, or whatever else presents itself. "He," coming thus into constant use, suffers from the familiarity when standing before the word "will" as a sign of the future tense; it then sinks into the vowel "U" pronounced hard; "u'll die," "u'll vight," "u'll stond," "u'll run," are, in such a case, the usual modes of pronouncing "He will."

"As," in this dialect, obtains very commonly the powers of "which;" thus, "The 'ooman as I married," "The beast as I zauld," "The ru-oad as I gade," would be proper phrases in village colloquy in this district.
"Which," however, takes the place of "When," or "While" in many cases. As "I bid the wench shou'd hauld awpen the gēat, which she slammed un to, and laughed in muv veace;" "He took his woath as I layed the dtrap, which I did noa sich a theng."

The plural in "es," so constantly sounded in Chaucer, is still preserved in many words in this part of the Cotswold range. Thus "Ghosts" and "Posts" are constantly "Ghostés" and "Postés;" "Beasts" are "Beastés," and sometimes "Beastesses;" "Guests" and "Feasts" becomes "Guestés," and "Feastés:" Addison's joke upon the songs in the opera,

"When the breezes
Fan the treeses," etc.,

would not be discovered to be a satire in the villages under consideration. There can be no doubt but this is the adherence to ancient usage; and Kemble was certainly right in considering that Shakespeare intended "Aches" to be pronounced "Aitchés," as a dissyllable, (to which usage that great actor steadily adhered), because the word was so sounded down to the days of King Charles II. See *Hudibras, passim.*

In forming past tenses of verbs we often find words in use, which, if they ever obtained elsewhere, are now generally obsolete. It is impossible to give all the instances, but we will enumerate a few specimens. "Catched" is used instead of "Caught." "Raught" is made the perfect tense of "Reach"— this word will appear in the Glossary, together with Shakespeare's use of it. That inimitable poet supports his native dialect in the use of the word "Holp," as

ARTFUL-VERY.-*Mary*. "Don't keep a screougin 'o' me, John!" *John*. "Wh'oi bean't a screougin' on yer!" *Mary (ingenuously)*. "Well, y' can i' y' like, John!"

the past tense of "Help." In *Much Ado about Nothing*, act iii., sc. 2., Don John says, "I think he holds you well, and, in dearness of heart, hath holp to effect your marriage." This is an ancient form of the word "Help," and kept alive by our Bible; we find it in *Isaiah*, xxxi., 3., "He that is holpen shall fall down;" in *Daniel*, xi., 34., "They shall be holpen with a little help;" in *St. Luke*, i. 54., "He hath holpen his servant Israel," and in other passages; and let us remember that these archaisms now, accidentally but very happily, increase our reverence for the sacred text.

"Fot," or "Vot," are used as the past tense of "Fetch;" "Give-Gave," makes its past tense in this district "Gived," but by abbreviation "Gied;" by a farther contraction spoken "Gid," though, in some cases, the labours of the schoolmaster and the village Incumbent have advanced the more promising pupil as far as "Guv." Instances of irregularity in the formation of the perfect tense are, as we have said, perpetual.

The double negative is very usual, and in this custom Shakespeare frequently upholds his native district. We will adduce as instances, *Henry V*, act ii., sc. 4.

"*Dauphin*.— Though war—nor no known quarrel were in question."

Next, the *Two Gentlemen of Verona*, act ii., sc. 4.

"*Valentine*.— Nor to his service no such joy on earth."

Measure for Measure, act ii., sc. 1.

"*Escalus.*— No sir—nor I mean it not."
Merchant of Venice, act iv., sc. 1.
"*Shylock.*— So I can give no reason nor I will not."
The instances of this irregularity are so frequent with this poet, that the reader may readily discover more examples.

The double superlative also obtains a place in our dialect. "Most worst," or even "Most worstest," would excite no remark as an unnecessary pleonasm. Shakespeare slips also into this practice: in *Henry IV*, Part II, act iii., sc. 1, we find —
"*King.*— And in the calmest and most stillest night."
This redundancy gains countenance from the words "Most Highest," as applied to the Creator in the Prayer-book version of the Psalms.
The double comparative is also very common. Not only "more better," but "more betterer," is usual. Shakespeare has this phrase also in *The Tempest*, act i., sc. 2: Prospero says —
"Nor that I am more better
Than Prospero."

"More braver" also is used in *The Tempest*, act i., sc. 2.
We constantly use the term "Worser;" and here again we gain countenance from the same poet. In *Hamlet*, act iii., sc. 4, this passage occurs —
"*Queen.*— O Hamlet, thou hast cleft my heart in twain.
"*Hamlet.*— Oh, throw away the worser part of it,
And live the purer with the other half."

Dryden also supports us in this usage; in the *Astræa Redux* we read at the 3rd line —
"And worser far
Than arms, a sullen interval of war."

In addition to the plurals in En still retained in the English language, which are Oxen, Brethren, Children, and Chicken, we have in familiar use in our district the words "Housen" for Houses, "Peasen" for Peas, and "Wenchen" for Wenches, "Elmen" for Elm Trees, and "Plazen" for Places. To these instances, we presume, we ought to add "Themmen" for Those, "Thairn" for Theirs,
"Ourn" for Ours, "Yourn" for Yours, "Thism" for These, together with "His'n," "Shiz'n," "Weez'n," as masculine, feminine, and plural of "His," "Hers," and "Ours';" with which irregularity we will close our notice of our grammatical varieties.

Some of the phrases in frequent use in dialogue on the Cotswolds, which will appear unusual to a stranger, are as follows:

"A copy of your countenance," means, "you are deceiving," "It is not yourself." Fielding, in his *Life of Jonathan Wild*, at the end of chapter 14 of Book iii, uses this expression. "But this he afterwards confessed at Tyburn was only 'a copy of his countenance.'"

"All manner" is a phrase used in an evil sense to describe all manner of annoyance; and is chiefly introduced to describe the carriage of any person who intrudes himself and acts as rudely as he pleases; thus, "He came and did all manner," would mean, "all manner of insolence or injury." Though this idiomatic expression is occasionally used by persons of better condition, we still do not remember to have seen it in use in any writings of a light or comic nature.

"All's one for that," means, "notwithstanding your objection, the case remains the same."

"Drap it, drap it!" that is, "Drop it." This is an angry request that any course of annoying remarks or practices may cease; and it may be safely concluded, when a genuine son of the Cotswolds uses this phrase, that his patience is just worn out.

"Gallows bad," "Gallows drunk," "a Gallows cheat"— always pronounced "Gallus" means, "bad enough for the gallows." It is possible that this may be a term of great antiquity, and may draw its frequent use from the gallows-tree of the feudal lord.

"Hand over head" is a metaphor taken from the conduct of a mob in a battle or in aggressive confusion, and is used to express anything done in haste, ill-order, and self-impeding perturbation. This phrase occurs in Farquhar's comedy, where Pindress, the maid-servant, urging the Page to marry her on the spot, exclaims, "No consideration! This business must be done hand over head."
Whereas, to do anything "with a high hand" always implies that it was some attempt triumphantly carried through.

"I cannot away with," is an ancient phrase, constantly found in the Bible, and still therefore in frequent use in this simple district, meaning, "I cannot cast away the recollection of it," I cannot endure it." It is used when speaking of some misfortune or bad conduct. See *Isaiah*, i, 13.

"I'll tell you what," is as much as to say, "I will give you an unanswerable argument;" sometimes it means, "I will give you my fixed resolution." Shakespeare perpetually uses this phrase; as an instance we may turn to *Henry IV*, Part I., act iii., sc. 1.

"*Hotspur.*— I'll tell you what, —
He held me, but last night, at least nine hours."

"It'll come right āāter a bit," means, "the difficulty in any business is

passing away."

"I can't be off it," means, "an irresistible impulse compels me to it," "I must do it."

"Let alone," is a statement that some necessary characteristic in any circumstance need not be taken into present calculation, as "A broken leg is zitch a hindrance, let alone the anguish of un!"

"May be" is continually used for "Perhaps" it is the *French* "Peut-être."

"Month's mind," means, a mind unsettled on any particular plan, a weak resolution. It is a term derived from a custom observed in the obsequies of remarkable persons previous to the Reformation. At the end of the month after the funeral there was a minor ceremony performed in recollection of the deceased, and which was intended to keep him in mind. A less procession, a less dole, and a less religious service took place; and, as these observances were all weaker in effect, and were necessarily of a very evanescent character, so any poor and wavering feeling came to be compared to "the month's mind" after a stately funeral. Thomas Wyndesor, Esq., in his will dated August 13, 1479, gives particular directions as to his funeral, which were designed with a view to very considerable state and dignity, and at the end of these is the following: "Item I will that there be one hundred children, each within the age of sixteen years, at my month's mind, to say our Lady's Psalter for my soul in the church of Stanwell, each of them having iiiid. for his labour, and that before my month's mind the candles burnt before the

A SLIGHT MISTAKE. —*Farmer.* "Where 'ave ye been all this time? And where's the old mare_ didn't ye have her shod as I told ye?" *Farge.* "Shod! Law no marster. I bin a buryin' she! Didn't I think thee said '*shot*'!"

rood in the said church be renewed and made at my cost; Item I will that at my month's mind my executors provide twenty priests, besides the clerks that come to sing Placebo, Dirige, etc., etc." *Testamenta Vetusta*, p. 393, in which work this practice is often alluded to. In Machyn's Diary this custom is also frequently noted; we will extract from it the notice of the deaths and month's mind of the two Dukes of Suffolk, who died while children, of the sweating-sickness. "The xxii day of September (1551) was the Monyth's Mind of the ii Dukkes of Suffoke in Chambryge-shyre, with ii Standards, ii baners-grett of Armes and large, and baners rolls of Dyver Armes, with ii Elmets, ii (swords), ii Targetts crowned, ii Cotes of Armes, ii Crests, and ten dozen of Scochyons crowned; and yt was grett peté of their dethe, and yt had plesyd God of so nobull a stok they wher, for ther ys no more of them left."

"Next of kin" does not mean relationship in blood, but any similarity. "Fainting" would be "next of kin to death," "A Glove — next of kin to the Hand;" "Fluid white-wash" would be "next of kin to Milk;" it means also any near relationship in place or authority; thus, a "Justice of the Peace" would be "next of kin to a Judge," an "Archdeacon" to "the Bishop," a "Lord-Lieutenant" to "the Monarch."

"Overseen" and "overlooked" means "bewitched"— led astray by evil influence, as having suffered under the "Evil Eye" of a witch or wizard. Thus, "I was quite overseen in that matter," means, "I had lost my reason by some evil agency."

"Play the bear," or "play the very Buggan with you," is to spoil, to harass; "Buggan" meaning Satan or any evil spirit — "Old Bogey."

"Poke the Fire," is always used instead of "Stir the Fire," and rightly, as having reference to the poker.

"Quite natural," means anything done easily, as a matter of course, and is spoken of proceedings which are quite artificial thus a man would be said to fly up in a balloon "quite natural."

"She is so" means a female expects to become a mother; probably this delicate phrase was originally accompanied with a position of the hands and arms in front of the person speaking, indicative of a promising amplitude.

"To and again," to move backwards and forwards, to go to a certain point and to return again, as on a terrace-walk in a garden. "To and fro" being, in fact, the same idea.

"You are such another," is a phrase used in derogation.

"You are as bad as the preceding." We find this phrase in *Much Ado about Nothing*, act. iii. sc. 4. "*Margaret* — Yet Benedict was such another, and now he is become a man."

"You'll meet with it," is a threat that punishment will unavoidably follow the course which is being pursued by the person addressed; the pronoun "it" being the abbreviation for chastisement.

"You might as well have killed yourself," is used to describe an accident which might have produced death, meaning "You have done enough to have killed yourself."

"You are another guess sort of a man," means "You differ from the example before us." Probably the word "Guess" in this phrase was originally "Guise."

"Whatever" frequently ends a sentence prematurely, the words "may happen," or "by any means," being struck off. It is mostly used negatively, as "I would not do it, — whatever." "He would not help himself, — whatever." This phrase, in spite of the ludicrous effect which attends it, is sometimes heard in the better walks of life in the Cotswolds.

We hardly know whether we ought to notice slip-slop, or the mistaken use of words introduced by the school-master; we will, however, remark that the phrase "It don't argufy," "edify," or "magnify," stands, whichever verb is selected, for "it does not signify." And when the honest rustic intends to be very emphatical and dignified at the same time he will frequently use all three errors; and having thus enriched his vocabulary with so many synonyms for "signify," he casts away the right word as being utterly useless.

The habit, however, of substituting the word "Aunt" for "Grandmother," which is very common in this district, deserves consideration, because we find this use of the word twice in Shakespeare. In *Othello*, act i. sc. 1, Iago alarms Brabantio with the intelligence of the elopement of his daughter with the Moor, whom he styles a "Barbary horse," and adds — "You'll have your nephews neigh to you," meaning grandsons; so again in *Richard III*, act iv. sc. 1, we have the stage direction — "*Enter Queen, Duchess of York, and Marquis of Dorset, at one door; Anne Duchess of Gloucester, leading Lady Margaret Plantagenet, Clarence's youngest daughter, at the other*" The Duchess of York addresses Lady Margaret with the words — "Who meets us here? My Niece Plantagenet," whereas she is her granddaughter. The grandmothers sometimes seem to take offence if they are denominated by any more ancient appellation than "Aunt" among their grandchildren.

The tone in which the Cotswold dialect is spoken is usually harsh, and the utterance is rapid, so that the conversations between the natives, marked by continual contractions, hasty delivery, and unusual words, is hardly understood by a stranger.

In presenting the reader with the Glossary which follows, we endeavour to give the derivation of each word from its original root, whenever we think we can suggest it with probability. In addition to this, where we can find the use of any word now nearly or quite lost, we have offered the quotation. These quotations we have, in most cases, verified; where we have not done this, we have adopted them chiefly on the authority of the *Encyclopedia Londinensis*.

These extracts from ancient writers, all, more or less, of authority, will

show that the old Gloucestershire words are not mere vulgarisms, but though now seldom or never used, are as well, if not better founded than those in common parlance; and it will be seen, in not a few instances, that the English language has lost rather than gained by adopting Latinisms in their stead.

We wish farther to remark that some of the words found in the following Glossary are not, strictly speaking, dialectical, but only still in continual use in this district, while they are dying rapidly in other places. As an instance, the word "Wag" appears in the Glossary. Now this word, in spite of the Scriptural use of it, as in the phrase "Wagging their heads," and in other passages, is almost limited to the motion of a dog's tail, while on the Cotswolds its general application is still preserved. A person who was standing in obstruction of any necessary work, would be addressed by the phrase "Why-'s 'nt Wag?" "why do you not move?" Such words are inserted to prolong the memory of terms, in themselves original and powerful, but which appear to be endangered by the use of words, more new but weaker, and drawn from a less efficient vocabulary.

NOTE

Nothing will need an apology which may tend to throw a light on any part of the life of Shakespeare. We will therefore without further preface, offer the following matter, kindly supplied to us by a friend residing at Dursley. We may take it for granted that the tradition which states how the young poet fled before the enraged face of Sir Thomas Lucy, on account of some illegal intrusion in the knight's park in Warwickshire, is based on some fact. It is surmised that he sought shelter in Dursley, a small town seated on the edge of a wild woodland tract. Some passages in his writings show an intimate acquaintance with Dursley, and the names of its inhabitants. In the Second Part of *Henry IV*, act v. sc. 1, "Gloucestershire," *Davy* says to *Justice Shallow* — "I beseech you, Sir, to countenance William Visor of Woncot, against Clement Perkes of the Hill."

This Woncot, as Mr. Stevens, the commentator, supposes, in a note to another passage in the same play (act v., sc. 3) is Woodmancot, still pronounced by the common people "Womcot," a township in the parish of Dursley. It is also to be observed that in Shakespeare's time a family named Visor, the ancestors of the present family of Vizard, of Dursley, resided and held property in Woodmancot. This township lies at the foot of Stinchcombe Hill, still emphatically called "The Hill" in that neighbourhood on account of the magnificent view which it commands. On this hill is the site of a house wherein a family named "Purchase," or "Perkis," once lived, which

LITTLE AND GOOD
Gentleman. "Who do these pigs belong to, boy?"
'Chaw.' "Why, this 'ere owd zow."
Gentleman. "Yes, yes; but I mean who's their master?"
'Chaw.' "Why, that there little 'un; he's a varmun to foight!."

seems to be identical with "Clement Perkes of the Hill." In addition to these coincidences, we must mention the fact that a family named Shakespeare formerly resided in Dursley, as appears by an ancient rate-book, which family still exist, as small freeholders, in the adjoining parish of Bagpath, and claim kindred with the poet. A physician, Dr. Barnett, lately residing in London, and who died at an advanced age, was in youth apprenticed at Dursley, and had a vivid remembrance of the tradition that Shakespeare once dwelt there; he affirmed, that losing his way in a ramble in the extensive woods which adjoin the town, he asked a person whom he met where he had been, and

was told that the name of the spot which particularly attracted his attention was called "Shakespeare's walk." In the play "*King Richard II, act ii. sc. 3,*"a description of Berkeley Castle is given, which is so exact that it is hardly possible to read it without considering it as if seen from Stinchcombe Hill. The scene is "A Wild Prospect in Gloucestershire."*Bolingbroke* and *Northumberland* enter; *Bolingbroke* opens the dialogue: —

"How far is it, my lord, to Berkeley, now?
North.— I am a stranger here in Gloucestershire;
These high wild hills and rough uneven ways
Draw out our miles, and make them wearisome."
"But, I bethink me, what a weary way
From Ravenspurg to Cotswold will be found
In Ross and Willoughby wanting your company," etc.
Enter to them *Harry Percy*, whom *Northumberland* addresses:—
"How far is it to Berkeley? And what stir
Keeps good old York there, with his men of war?
Hotspur.— There stands the castle by yon tuft of trees."

Now this is the exact picture of the castle as seen from "The Hill;" the castle having been, from time immemorial, shut in on one side, as viewed therefrom, by an ancient cluster of thick lofty trees. Lastly, we would add that down to the reign of Queen Anne the Cotswold range was an open tract of turf and sheep-walk, which extended up into Warwickshire, and was famous as a sporting-ground, particularly for coursing the hare with greyhounds, throughout the whole extent. It was consequently well-known by the gentry of both counties; and this is evidenced by their pedigrees, wherein intermarriages between the houses of each county are frequently found. The portion of Shakespeare's life which has always been involved in obscurity is the interval between his removal from Warwickshire and his arrival in London; and this period, we think, was probably spent in a retreat among his kindred at Dursley, in Gloucestershire.

GLOSSARY

Ā-ĀTER. After, in point of time; also, according to, in point of manner: "Āāter this fashion."

ABIDE. To endure, to suffer: Abidian, *Saxon.*
 "The nations shall not be able to abide his indignation." *Jer.* x., 10.
 "The day of the Lord is great and very terrible, and who can abide it."

Joel ii., 11.

Used in the same sense by Robert of Gloucester and Peter Langtoft.

ADRY. Thirsty: Adrigan, *Saxon*.

AFEARED. Frightened: Afæran, *Saxon*.
> "Whether he ben a lewdé or lered,
> He n'ot how sone that he may ben affered."—Chaucer, *Doctor's Tale*,
> l. 1221.

See also Spenser's *Fairy Queen*.

AFORE, ATVORE. Before: Atforan, *Saxon*.

AGEN. Opposite to, over against. This word is also used to designate any given time for the occurrence of an event, or the performance of a promise: Agen, *contra*, *Saxon*.
> "I'll be ready agen Zhip-Zhearin," or "Luk for't agen Mī-ēlmas."
> "Even agen France stonds the contre of Chichestre,
> Norwiche agen Denemarke," etc., etc. *Robert of Gloucester*. Hearne's Edition, 1714, Vol. I., p. 6.

ANEAL. To mollify, to shape by softening.
> "Thus was I, sleeping, by a brother's hand
> Of life, of crown, of queen, at once dispatched;
> Cut off even in the blossoms of my sin,
> Unhouseled, disappointed, unanealed."—Shakespeare, *Hamlet*, act i. sc. 4.

See also the receipt for "Anealing your Glass" when "you would paint there." Henry Peacham, *Compleat Gentleman*, Vol. II., lib. I., p. 96.

ANEAWST, ANNEARST, ANIGSHT. Near; also, metaphorically, resembling: Near, *Saxon*.
> "*Host.* Will you go an-heirs?
> *Shallow.* Have with you, mine host."—Shakespeare, *Merry Wives of Windsor*, act ii. sc. i.

ANUNST. Over against, opposite to: Nean, *Saxon*.

ARTISHREW. The shrew-mouse, an animal used in magical charms:
> "Shrew," and "arte" to compel, Sir Walter Scott writes, *Scottice*, "Airt."
> "A tiraunt would have artid him by paynes."—Bootius, MS. Soc. Antiq. 134, f. 296.

ATHERT. Athwart, across: Thwur, *Saxon*.
> "All athwart there came
> A post from Wales, laden with heavy news."—Shakespeare, *King Hen. IV*.

ATTERMATH. Grass after mowing: "After" and "Math," from Mathan, *Saxon*, to mow.

AWAY WITH. To bear with, to suffer, to endure.
"*Shallow.*—She never could away with me
Falstaff.—Never—never; she would always say, she could not abide
Master Shallow." — Shakespeare, *Henry IV*, Part II. act iii. sc. 2.
"The new moons and sabbaths, the calling of assemblies, I cannot away with." *Isaiah* i. 13.
"*Moria.*—Of all the nymphs i' the court, I cannot away with her; — 'tis the coarsest thing!" Ben Jonson, *Cynthia's Revels*, act iv. sc. 5.

AXE. To ask: Axian, *Saxon*.
"Axé not why;—for though thou axé me,
I woll not tellen Godde's privetee."—Chaucer, *Miller's Tale*, 1. 3557.
"What is this to mene, man, maiste thee axe." — Deposition of Ric. ii.

AXEN. Ashes; *also* in the sense, cineres: Axan, *Saxon*.
"Yn'ot whareof men beth so prute,
Of erthe and axen, felle and bone,—
Be the soule's enis ute,
A viler carsang n'is there none." Song *temp*. Edw. I.

COMPLIMENTS OF THE SEASON.—*Farmer's Wife (to little rustic, her protegé)*. "Well. Sam, your master and I are going up to London for the cattle show." *Cow Boy*. "oh, i'm sure I hope yeou'll take the fust prize, m'-that I dew!"

B.

BACK-SIDE. The backfront of a house.
"He led the flock to the backside of the desert."—*Exodus* iii. 1.

BAD. To beat husks, or skins of walnuts, or other fruits:
Battre, *French*.

BAG. The udder of a cow; *also* a sack.

BALD-RIB. The piece otherwise called the "spare-rib," because moderately furnished with meat.

BANDORE. Violoncello or bassoon: Pandura, a similar Italian instrument.

BANGE. *A gamekeeper's word*, to express the basking and dusting themselves by feathered game.
Bang-a-bonk—to lie lazily on a bank.—James Orchard Halliwell, *Dictionary of Archaic and Provincial Words*.

BAN-NUT. The walnut: Baund, swelling, *Danish*; Thnut, *Saxon*.

BARKEN, BARTON. The homestead: Bairton, *Goth*, to guard.
"I were never afeared but once, and that ware of grandfar's ghost,—for he always hated I,—and a used to walk, poor zoul, in our barken."—Susannah Centlivre, *Chapter of Accidents*, act ii. sc. 1.

BARM. Yeast: Beorm, *Saxon*.
"And sometimes make the drink to bear no barm."—Shakespeare, *Midsummer Night's Dream*, act ii. sc. 1.

BARROW-PIG. The hog, a gelt Pig: Barren?

BASS OR BAST. Matting used in gardens.

BASTE. To beat: Bastre, *old French*.

BAT-FOWLING or BAT-BIRDING. Taking birds by night in hand-nets.
"*Sebastian.*—We would so,—and then go bat-fowling."—Shakespeare, *Tempest*, act ii. sc. 1.

BAULK. A bank or ridge: Balc, *Saxon*.
"And as the plowman, when the land he tills,
Throws up the fruitful earth in rigged hills,
Between whose chevron-form he leaves a balke,
So 'twixt these hills hath nature framed this walke,'—William Browne, *Britannia's Pastorals*, i. 4.

BEASTS. Horned cattle.

BEHOLDEN. Indebted to.

BELLY. A verb. To swell out.

BELLUCK. Bellow: Bellan, *Saxon*.
"As loud as belleth winde in hell."—Chaucer, *House of Fame*, iii. 713.

BENNET, BENT. Dry, standing grass: Biendge, *Teuton*.
"The dryvers thorowe the woodés went
For to rees the deer,—
Bowmen bickered upon the bent
With their browde arrowes clear."—Chevy Chase.

BESOM. A word of reproach, applied solely to the fair sex; as, "Thee auld besom:" Perhaps derived from the besom on which a witch rides; but very likely the same word with "bison," which, in the northern dialects, means a shame or disgrace; a woman doing penance was called a "holy bison."—John Trotter Brockett, *Glossary of North Country Words*.

BETEEM. To indulge with: Tœman, *Saxon*.
"So would I, said the Enchanter, glad and fain
Beteem to you his sword."—Spenser.
"Belike for want of rain, which I could well
Beteem them from the tempest of mine eyes."—Shakespeare,
Midsummer Night's Dream, act i. sc. 1.
"That he might not beteem the winds of heaven
Visit her face too roughly."—Shakespeare, *Hamlet*, act i. sc. 2.

BIDE. To stay, to dwell: Bidon, *Saxon*.
"*Pisano.*—If not at court,
Then not in Britain must you bide."—Shakespeare, *Cymbeline*, act iii. sc. 2.
"All knees to Thee shall bow of them that bide
In heaven, or earth, or under earth in hell."—Milton.

BIN. Because: contracted from "It being."
"*Leon.*—Being that I flow in grief,
The smallest twine may lead me."—Shakespeare, *Much Ado About Nothing*, act iv. sc. i.
"*La-poope.*—And being you have declined his means, you have increased his malice." Beaumont and Fletcher, *Honest Man's Fortune*, act ii.

BITTLE. Beetle, a heavy mallet used to ram down pavements, etc.: Bitl, *Saxon*.
"Falstaff.—If I do, fillip me with a three-man beetle."—Shakespeare,
Henry IV, Part II., act i. sc. 2.

BLATHER. To talk indistinctly, so fast as to form bladders at the mouth.

BLIND-WORM. A small snake, the slow-worm.

"Adder's fork and blind-worm's sting."—Shakespeare, *Macbeth*, act iv. sc. 1.

BLOWTHE. Blossom in orchards, bean fields; cinquefoin, etc.: Blawd, *Welsh*.
"Ambition and covetousness being but green and newly grown up,
the seeds and effects were as yet but potential,
and in the blowth and bud."—Sir Walter Raleigh.

BODY, An individual; often spoken of oneself, "A body can," or "A
body can't."
"Good may be drawn out of evil, and a body's life may be saved
without any obligation to the preserver." Sir Roger L'Estrange.

BOOT. Help, defence: Bot, *Saxon*.
"Then list to me, St. Andrew be my boot.—Pinner of Wakefield, iii. 19.
See also Old Ballads, and Shakespeare, *passim*.

BOTTOM. A valley.
"Dunster Toun stondithin a bottom"—Leland's *Itinerary*.
"*Hot.*—It shall not wind with such a deep indent,
To rob me of so rich a bottom here."—Shakespeare, *Henry IV*, Part I.,
act iii. sc. 1.
"Pursued down into a little meadow which lay in a bottom."
Autobiography of King James II., Vol. I., p. 213.
"On both the shores of that beautiful bottom." Addison, *Remarks on
Italy*, 5th Ed., p. 152.

BRAKE. A small coppice: Brwg, *Welsh*.
"*Escalus.*—Some run through brakes of vice."—Shakespeare, *Measure
for Measure*, act ii. sc. 1.
"'Tis but the fate of place, and the rough brake
That virtue must go through."—Shakespeare, *Henry VIII*, act i. sc. 2.

BRASH. Light, stony soil: Trash?

BRAVE. Healthy, strong in appearance.
"——A brave vessel,
Who had, no doubt, some noble creatures in her,
Dashed all to pieces."—Shakespeare, *Tempest*, act i. sc. 2.

BRAY. Hay spread abroad to dry in long parallels: Brœd, *Saxon*.

BREEDS. The brim of a hat: Brœd. *Saxon*, as laid out flat.

BRIM, BREM. Spoken of a sow, as also of a harlot: Bremen, Ardere
desiderio; John Trotter Brockett, *Glossary of North Country Words*.
Peter Langtoft uses this word in the sense "furious."

BRIT. Spoken of the shedding of over-ripe corn from the ear. Chaucer's

word "bretful" is probably "full to bretting." It seems the root of "brittle."
"His wallet lay before him in his lappe
Bret-ful of pardon, come from Rome al hote."—Chaucer, *Canterbury Tales*, Prologue, 1. 689.
"A mantelet upon his shoulders hanging
Bret-ful of rubies red, as fire sparkling."—Id., *The Knighte's Tales*, 1. 2166. "They blew a mort upon the bent,
They 'sembled on Sydis sheer,
To the quarry the Percy went,
To see the brittling of the deer."—Chevy Chase.
"With a face so fat
As a full bladere
Blowen bret-ful of breth."—Creed of *Piers Plowman*, 1. 443.

BRIZZ, BREEZE. The gad-fly: Briosa, *Saxon*.
"The herd hath more annoyance from the breeze,
Than from the tyger."—Shakespeare, *Troilus and Cressida*, act i. sc. 3.

BROOK. To endure, to bend to opposition or evil: Brucan, *Saxon*.
"——Heaven, the seat of bliss,
Brooks not the works of violence or war."—Milton.

BROW. The abrupt ridge of a hill: Brœw, *Saxon*.
"——And to the brow of heaven
Pursuing, drave them out from God and bliss."—Milton.
"And after he had upon the brow of the hill raised breastworks of faggots." Lord Clarendon, describing the battle of Lansdown.

BROW. Adjective. Brittle, liable to snap off suddenly: Brau, *Welsh*.

BUCKING. The foul linen of a household collected for washing: Buc, *Saxon*; Lagena?
"Throw foul linen upon him, as if it were going to bucking."—Shakespeare, *Merry Wives of Windsor,* act iii. sc. 3.

BUDGE. To move a very short distance: Bugan, *Saxon*; Buj, *Sanscrit*.

BUFF. To stammer: derived from the sound.

BULL-STAG. A bull castrated when old.

BURNE, BURDEN. Spoken of as much hay or straw as a man can carry: Bwrn, *Welsh*, a truss.

BURR. Pancreas of a calf, the sweet-bread: Bourre, *French*.

BURROW. Any shelter, especially from weather: Burh, *Saxon*.

BUTTY. A comrade in labour: Bot, *Saxon*.

C.

CADDLE. To busy with trifles; to confuse; to vex: Caddler is, we believe, *Old French*, with the same sense.

CADDLEMENT. A trifling occupation; confusion; vexation.

CANDER. Yonder: Geonda, *Saxon*.

CANDER-LUCKS. Look yonder.

CANDLE-MASS BELLS. The snowdrop.

CANDLE-TINNING. Candle-lighting; evening: Tinan, *Saxon*, and candle.
"Love is to myne harte gone, with one spere so kene,
Night and day my blood it drynks, mine herte doth me tene."—MS.
Harl. Miscell.
"The priests with holy hands were seen to tine
The cloven wood, and pour the ruddy wine."—Dryden.
"Spiteful Atin, in their stubborn mind,
Coals of contention and hot vengeance tined."—Spenser's *Fairy Queen*.
"Kindle the Christmas brand, and then
To sunset let it burne;
Which quencht, then lay it up agen
Till Christmas next returne."
"Part must be kept wherewith to teend
The Christmas log next yeare;
And where 'tis safely kept, the fiend
Can do no mischief there."—Herrick.

CANT. To toss lightly, to cast anything a small distance.

CARK. Care: Carc, *Welsh*.

CESS. A word used in calling dogs to their food. Probably in monastic halls the portions assigned to the brotherhood were originally called cessions, and the word was jocosely transferred afterwards to the knight's kennel: Cessio, *Latin*.
"The poor jade is wrung in the withers out of all cess."
Here the word means "out of all measure."—Shakespeare, *Henry IV.*, Part I, act ii. sc. 1.

CHAM. To chew: Cham, *Sanscrit* (?) to eat.

CHAR, or CHIR. A job; hence charwoman: either Jour, *French*, as hired by

EDUCATION.—*Squire*. "Hobson, they tell me you've taken your boy away from the national school. What's thst for? *Villager*. "Cause the master ain't fit to teach un!" Squire. "O, I've heard he's a very good master." *Villager*. "Well, all I knows is, he wanted to spell 'taters' with a 'p!!!"

the day, or Cyrre, *Saxon*, labour.
"And when thou'st done this chare, I'll give thee leave
To play till Doomsday."—Shakespeare, *Anthony and Cleopatra*, act v. sc. 2.

CHARM. A noise; a clamour: Cyrm, *Saxon*.

CHATS. The chips of wood when a tree is felled.

CHAUDRON. Entrails of a calf; *metaphorically*, any forced meats or
stuffing put in the crops of birds sent to table: Caul, *Welsh* (?)
"Add thereto a tyger's chawdron."—Shakespeare: *Macbeth*, act iv. sc. 1.
"Swan with chaudron."—*Relation of the Island of England* by an
Italian, A.D. 1500, note 79.

CHAW. To chew. It may be merely the Cotswold pronunciation of chew:
Chaw was formerly written for jaw.
"I will put hookes in thy chawes."—*Ezekiel* xxix. 4, and again xxxviii.
4, Breeches Bible.

CHAWN. To gape. Spoken of apples chipped in the rind, viz., the chawn-
pippin; also the earth opening in dry weather: Χαυνω *Greek* Probably
of Indo-Germanic origin, and a word in use both by the Greeks and
the Teutonic tribes.
"O thou all-bearing earth,
Which men do gape for, till thou cramm'st their mouths,

And choak'st their throats with dust; O chaune thy breast,
And let me sink into thee."—Ant. and Mell. Anc. Dr. II. 144. See
Nares's Glossary.

CHILVER A ewe-lamb: Cilfer, *Saxon*.

CHISSOM. To bud forth. Especially applied to the first shoots in newly cut
coppice.

CHOCK-FULL. Full to choking.

CHURK. The udder of a cow: Cirt, *Saxon*, benignitas, largitas,
metaphorically used (?)

CLAMMY. Adhesive, sticky: This may be a metaphor drawn from the
Shropshire word "Clem," to starve; because the skin then adheres
closely to the attenuated frame.

CLAVEY. Mantle-piece; chimney-piece: Claddé, *Welsh*.

CLAY-RAG. A composite stone, found in clay-pits.

CLEATS. A small wedge, commonly of wood.

CLEAVE. To cling to; also to burst hard bodies asunder by wedges:
Clifian, *Saxon*.
"The clods cleave fast together."—*Job*, xxxviii. 38.
"The men of Judah clave unto their king."—II. *Samuel*, xx. 2.
"The thin camelion, fed with air, receives
The colour of the thing to which he cleaves."—Dryden.
"Like our strange garments, cleave not to their mould,
But with the aid of use."—Shakespeare.
"The priests with holy hands were seen to tine
The cloven wood."—Dryden.

CLITES. A plant, cleavers; Galium Aparine: Clate *Saxon*.
"A clote-lefe he had laid under his hode."—Chaucer. *Chanon's Yeman's
Prologue*.

CLOUT. A heavy blow; Clud, *Saxon*; metaphorically derived from the
clouded and swelled appearance caused by a heavy blow.

CLYP. To embrace: Clippan, *Saxon*.
"That Neptune's arms, who clippeth thee about,
Would bear thee from the knowledge of thyself."—Shakespeare, *King
John*, act v. sc. 2.

COLLY. Subst., Dirt, *also* the blackbird; Adject., black, dark; Verb, to
defile: Coal (?) In *Spanish* Hollin is soot.
"Brief as the lightning in the collied night."—Shakespeare, *Midsummer*

Night's Dream, act i. sc. 1.

"Nor hast thou collied thy face enough, Stinkard !"—Ben Jonson, *Poetaster,* act iv. sc. 5.

COLT. A landslip.

COMB. A valley with only one inlet: Comb, *Saxon.*

CONCEIT. To think, to believe; Subst, A strong mental impression: Concipio, *Latin.*

"The strong, by conceiting themselves weak," etc.—Dr. South.

"One of two bad ways you must conceit me,
Either a coward or a flatterer."—Shakespeare.

"A blunt country gentleman, who understanding but little of the world, conceited the earth to be fastened to the North and South poles by great and massy cakes of ice."—*Hagiastrologia,* J. Butler, B.D. 1680, p. 45.

"The same year Sir Thomas Egerton, the Lord Chancellor, died of conceit, fearing to be displaced."—*Diary of Walter Yonge, Esq.,* 1619, p. 33.

COO-TER. The wood pigeon's note.

COUNT. To consider; to suppose: Compter, *French.*

"Count not thy hand-maid for a daughter of Belial."—I. Samuel, i. 16.

"Nor shall I count it heinous to enjoy
The public marks of honours and rewards."—Milton.

COURT-HOUSE. The manor-place, so called because the lord held his manor-court there.

CRANK. A dead branch of a tree: Krank, *Dutch,* sick, weakly.

CRAZY. A plant—the *Ranunculus Acris.*

CRINCH. A morsel: Crunch, *Sanscrit,* to lessen, to diminish.

CROWNED. A pollard is said by the woodwards to be crowned, when the rind has healed over the wound.

CUCKOLD. The seed-pod of the Burdock; as being shaped like the human head, and covered on all sides by little horns(?)

CULL. A small fish, the miller's thumb: Callan, *Sanscrit,* a small fish.

D.

DĀĀK. To dig up weeds: Daque, *French.*

DADDLES. Said, playfully, of the hands: Tatze, *German.*

DADDOCKY. Said of decayed timber: Quasi, dead oak(?)

DAP. To sink and rebound: Doppetan, *Saxon*.

DAP-CHICK. A bird, the little grebe, one of the divers.

DAY-WOMAN. Dairy-maid: Deggia, *Icelandic*, to give suck.
"For this damsel, I must keep her at the park; she is allowed for the day-woman."—Shakespeare, *Love's Labour Lost*, act i. sc. 2.

DEADLY. A word meaning intenseness in a bad sense, as "deadly lame," "deadly sore," "deadly stupid," etc.

DENT. An indentation: Dens, *Latin*, a tooth.

DESIGHT. A blemish.

DESPERD. Beyond measure, extremely: used in an evil sense: Desperate.

DISANNUL. To annul; a reduplication of the sense: Nullus, *Latin*.
"The Lord of Hosts hath purposed, and who shall disannul it?"—*Isaiah*, xiv. 27.
"Wilt thou also disannul my judgment!"—*Job*, xl. 8.
"For there is verily a disannulling of the commandment."—*Hebrews*, vii. 18, and in other places in the Bible.
"Pope Pius the Fourth reflecting on the capricious and high answer his mad predecessor had made to her address, sent one Parpalia to her, in the second year of her reign, to invite her to join herself to that See, and he would disannul the sentence against her mother's marriage."—Bishop Burnet, *History of the Reformation*, Part II. bk. iii. p. 417, fol. ed. 1681.
"Then I might easily disannul the marriage.
Scapin. Disannul the marriage!"—Otway, *Cheats of Scapin*, act i. sc. 1.

DISMAL. Any evil in excess "He do cough dismal!"

DOFF. To take off clothing: Do-off(?)
"He that unbuckles this, till we do please
To doff't for our repose, shall bear a storm."—Shakespeare, *Anthony and Cleopatra*, act iv. sc. 4.

DOLLOP. A lump; a mass of anything.
"Of barley, the finest and greenest ye find,
Leave standing in dallops, till time ye do bind."— Thomas Tusser, *Five Hundred Points of Good Husbandry*, August 17.

DON. To clothe; to put on: Do-on?
"Menas, I did not think
This am'rous surfeitor would have donn'd his helm."—Shakespeare,

Anthony and Cleopatra, act ii. sc. 1.

"Then up he rose and donned his clothes."—*Hamlet*, act iv. sc. 5.

"Some donned a cuirass, some a corselet bright."—Fairfax, translation of Tasso, *Jerusalem Delivered*, i. 72.

DORMOUSE. Applied to the bat, because he sleeps in winter: dormio, *Latin*.

DOUT. To extinguish a light; to put out a candle: Do out(?)

"First, in the intellect it douts the light." Sylvester, *Tobacco battered*, 106. 1620.

DOWLE. Down on a feather; the first appearance of hair: Probably, Down, corruptly used.

"May as well

Wound the loud winds, or with be-mockt-at stabs

Kill the still-closing waters, as diminish

One dowle that's in my plume."—Shakespeare, *Tempest*, act iii. sc. 3.

DRAVE, the same word as Thrave. A truss of straw; and by metaphor, a flock of animals, a crowd: Thraf, *Saxon*.

"They come in thraves to frolic with him."—Ben Jonson.

DRINK. Used as a term for beer; and limited to that beverage.

"And sometimes make the drink to bear no barm."—Shakespeare, *Midsummer Night's Dream*, act iii. sc. 3.

DROXY. Spoken of decayed wood: Drogenlic, *Saxon*.

DRUNGE. To embarrass, or perplex by numbers: Throng(?) mispronounced.

DTHONG. Painful pulsation: Stang(?) *Icelandic*, same sense.

DUDDLE. To stun with noise: Dyderian, *Saxon*.

DUDGEON. Ill-temper; *also* the dagger, as the result thereof.

"When civil dudgeon first grew high,

And men fell out, they knew not why."—Samuel Butler, *Hudibras*.

DULKIN, DELKIN. A small, but dark descent; a ravine; Dell, or dale, with kin as a diminutive.

DUMMLE. Dull, slow, stupid: Dom, *Dutch*.

DUNCH, DUNNY. Deaf; also imperfection in any of the faculties.

"What with the zmoke, and what with the criez,

I was a'most blind, and dunch in my eyez."—MS. Ashmole, 36, f. 112.

See Halliwell's *Dictionary*.

DUP. To exalt; do up(?) Possibly a metaphor from the portcullis.

DURGAN. A name found for a stocky, undersized horse, in all large teams: Dwerg, *Saxon*, a dwarf.

DWĀ-ĀL. To ramble in mind: Dwa-elen, *Teuton*.

DWAM. To faint away.

DYNT. The impression made by a heavy blow: Dynt *Saxon*.

E.

EIRY. Spoken of a tall, clean-grown timber sapling. Possibly, as tall enough to be chosen by the hawk for her eiry(?)

ELVER. A small eel: El, *Saxon*.

ENTENNY. The main doorway of a house: Always so mispronounced.

ETTLES. Nettles: A common mispronunciation.

EYAS. A young hawk: *A falconer's term*, not yet lost, derived from Eye; (as next below.) See *Hamlet*, act ii. sc. 2.

EYE. A brood of pheasants: Ey, an egg, *German*.
"Sometimes an ey or tway."—Chaucer, *The Nonnes Priest's Tale*, 1. 38.
"Unslacked lime, chalk, and gliere of an ey."—Chaucer, *The Chanones Yeman's Tale*, 1. 252.
"The eyren that the hue laid."—Deposition of King Richard II.

F.

FAGGOT. A word applied in derogation to an old woman, as deserving a faggot for witchcraft or heresy.

FALL—of the year. Autumn: Falewe, *Saxon*; to grow yellow: the colour fallow.

FEND. To forbid; to defend: Defendre, *French*.

FILLS—see also TILLS, THILLS, TILLER-HORSE. The shafts of a cart: Thill, *Saxon*.
"If you draw backwards we'll put you in the fills."—Shakespeare, *Troilus and Cressida*, act iii. sc. 2.

FILTHY, VILTRY. Filth of any kind; weeds in cultivated land.

FLAKES, FLE-AK. A wattled hurdle.

FLAT. A common term for a low, concave surface in a field.

FLICK. Verb. To tear off the skin or felt by the smack of a whip, or the hasty snap of a greyhound when he fails to secure the hare; Subst., the fat between the bowels of a slaughtered animal.
"I'll lend un a vlick." —Henry Fielding, *Tom Jones.*

FLOWSE, FLOWSING. Flowing, flaunting: Fliessen, *German.*
"They flirt, they yerk, they backward fluce, they fling,
As if the devil in their heels had been."—Michael Drayton,
Sir John Oldcastle.

FLUMP. Applied to a heavy fall "he came down with a flump:" Plump(?)

FLUSH, or FLESHY. Spoken of young birds fledged.

FORE-RIGHT. Opposite to: Foran, *Saxon.*

FOR-WHY. Because; on account of: For-hwe, *Saxon.*
"For why The Lord our God is good."—100th Psalm, Old Version.
"For why? He remembered His holy promise."—Psalm cv. 42,
Prayer-book Version.

FRITH. Young white thorn, used for sets in hedges: Ffrith, wood, *Welsh.*
"To lead the goodly routs about the rural lawns,
As over holt and heath, as thorough frith and fell."—*Michael Drayton.*
"He hath both hallys and bowrys,
Frithes, fayr forests, and flowrys."—*Romance of Emaré.*
"When they sing loud in frith or in forest."—Chaucer.

FRORE, FROR. Frozen: Frieren, *German.*
"The parching air
Barns frore, and cold performs the part of fire."—Milton.
"And some from far-off regions frore."—Bishop Mant, *British Months,*
January, 708.

FROM-WARD, FROM-MARD. Opposite to Toward.

FRUM, FROOM, FRIM, FREM. Full, abundant, flourishing: From, *Saxon.*
"Through the frim pastures at his leisures."— Michael Drayton.

G.

GAITLE. To wander idly: Ge-gada, *Saxon.*

GAITLING, GADLING. An idler; a loiterer.
"When God was on earth and wandered wide,
What was the reason why he would not ride?
Because he would have no groom to go by his side,

Nor discontented gadling to chatter and chide."—Old Song, Wright's *House of Hanover*.

GALLOW. To alarm; to frighten: Agælan, *Saxon*.
"The wrathful skies
Gallow the weary wanderers of the night."—Shakespeare, *King Lear*, act iii. sc. 2.

GALLOWED, or GALLARD. Frightened.

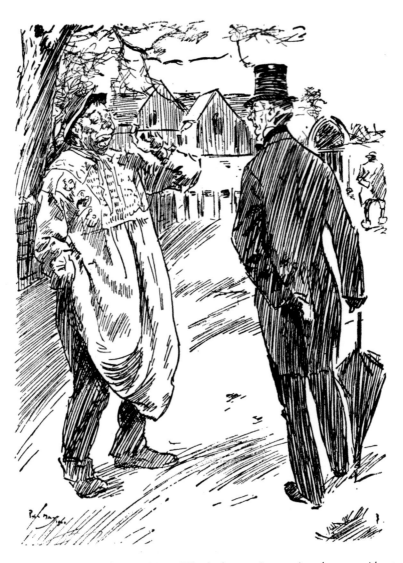

The Vicar. "I'm surprised at *you*, Miggs. Why, look at *me*. I can go into the town without coming back intoxicated." *Miggs*. "Yesh, zur, but *Oi* be so popular!" (Hic.)

GALORE. An exclamation signifying abundance: Gulori, *Gaelic*.
Frequent in ballads. See Sibbald's, Bitson's, and Percy's Collections.

GAMUT. Sport: Gamen, *Saxon*; Gaman, *Icelandic*.
"And that never on Eldridge come
To sport, gamon, or playe."—Percy's *Reliques*, *Sir Cauline*. 112.
"All wite ye good men, hu the gamon goth."—Political Song, Wright,
p. 331, l. 180.
"There was a gamon in Engelond that dured zer and other,
Erliche upon the Munday uch man bishrewed others;
So long lasted that gamon among lered and lewed,
That n'old they never stinten, or al the world were bishrewed."—
p. 340, l. 367.

GAULY, GAUL, GALL. Sour marsh-land, metaphor taken from "gall,"a
wound; which sense is also in common use: Gealla, *Saxon*.

GAYN, and its contradictory, UN-GAYN. Happily advantageous; lucky.

GEAR. Harness; apparel: Gearwa, *Saxon*.
"The frauds he learned in his frantic years,
Made him uneasy in his lawful gears."—Dryden.

GICK, GĒ-ĀK, KECK, KEXIES. Dry stalks, more especially of the tall,
umbelliferous plants; Geac, *Saxon*.
"And nothing teems
But hateful docks, rough thistles, kexies, burs."—Shakespeare, *Henry
V.*, act v. sc. 2.
"If I had never seen, or never tasted
The goodness of this kix, I had been a made man."—Beaumont and
Fletcher, *Coxcomb*, act i. sc. 2.
"With wyspes, and kexies, and rysches ther light
To fetch hom their husbandes, that wer them trouth-plight."—Ritson,
Antient Songs, Tournament of Tottenham, p. 93.

GIMMALS. Hinges: Gemelli, twins, *Latin*.

GLOWR. To stare moodily, or with an angry aspect; Gluren, *Teuton*.

GLOUT. To look surly or sulky: Gloa, *Suio-Gothic*.
"Glouting with sullen spight, the fury shook
Her clotted locks."—Sir Samuel Garth, *The Dispensary*.

GLUM, GLUMP. Gloomy; displeased: Glum, *Teuton*.
"Whiche whilom will on folké smile,
And glombe on hem an othir while."—Chaucer, *Romaunt of the Rose*,

1. 4356.

GODE. Past tense of To go, often softened into yode.
"As I yod on a Monday
Bytweene Wiltinden and Walle."—Ritson, *Ballad on the Scottish War*, 1. 1.
"In other pace than forth he yode
Beturned Lord Marmion."Sir Walter Scott, *Marmion*, canto iii. xxxi.

GRIP. A drain: Græp, *Saxon*.

GRIT. Sandy, stony land: Gritta, *Saxon*.
"Pierce the obstructive grit and restive mail."—Phillips.

GROANING. Parturition: *metaphorically used.*
"You may as safely tell a story over a groaning-cheese, as to him."—
Farquhar, *Love and a Bottle*, act ii.

GROUNDS. Commonly used for fields, and those usually grass-lands.

GROUTS, GRITS. Oatmeal; also dregs: Grut, *Saxon*.
"King Hardicnute, 'midst Danes and Saxons stout,
Caroused on nut-brown ale, and dined on grout."—King. Quoted by
Thomas Tegg, *The London Encyclopedia, or Universal Dictionary of
Science*, 1829.
"Sweet boney some condense, some purge the grout."—Dryden.

GULCH. A fat glutton: Gulo, *Latin*.
"You'll see us then, you will, gulch."—Ben Jonson, *Poetaster*,
act iii. sc. 4.
"Thou muddy gulch, darest look me in the face?"—Cobham Brewer,
Lingua Franca.

GULLY. A deep, narrow ravine, usually with a rill therein: Gill, *North
country dialect*.

GUMPTION. Spirit; sense; quick observation: Gaum, *Icelandic*.
"Within two yer therafter some to Morgan come,
And, for he of the elder soster was, bed him nyme gome."—Robert of
Gloucester, p. 38, Hearne's Ed.
"An eh, troth, Meary, I's as gaumless as a goose."—Tim Bobbin, p. 52.

GURGINS. The coarser meal of wheat: quasi Purgings(?)

H.

HACKLE. *A gamekeeper's word*; To interlace the hind-legs of game for
convenience of carriage, by houghing the one and slitting the film of

the other limb.

HAINE. To shut up a meadow for hay: Haye, a hedge, *French*.

HALE, pronounced "Haul." To draw with violence, or with a team: Hāā-len, *Dutch*.
"Lest he hale thee to the judge."—*St. Luke*, xii. 58.

HAMES, plural HAMES-ES. The wooden supports to a horse-collar in teams; made of metal in coach-harness.

HANDY. Near; convenient; when applied to an individual, clever: Gehend, *Saxon*.

HANK. A skein of any kind of thread.

HARBOUR. To abide; to frequent: Herebeorgan, *Saxon*.
"This night let's harbour here in York."—Shakespeare.
"Let not your gentle breast
Harbour one thought of outrage from the king."—Nicholas Rowe.

HARSLET. The main entrails of a hog: Hasla, *Icelandic* a bundle.
"There was not a hog killed in the three parishes, whereof he had not part of the harslet, or puddings."—Ozell's Rabelais, iii. 41. See Nares's Glossary.

HATCH. A door which only half fills the doorway.

HAULM. Dead stalks: Healm, *Saxon*,
"In champion countries a pleasure they take
To mow up their haum, for to brew or to bake."
"The haum is the straw of the wheat or the rie."— Thomas Tusser, *Five Hundred Points of Good Husbandry*, January 14, 15.

HAUNCHED. To be gored by the horns of cattle: from Haunch, where the wound would usually be inflicted.

HAY-SUCK. Hedge-sparrow: Hege-sugge, *Saxon*.
"Thou murdrir of the heisugge on the braunche
That brought thee forth."—Chaucer, *Assemblie of Fowles*, 1. 612.

HAYWARD. An officer appointed at the court leet, to see that cattle do not break the hedges of enclosed lands, and to impound them when trespassing. Hegge, *Saxon*.
"The Hayward heteth us harm."—Political Songs, temp. Edward I., p. 149. Wright.

HAZEN. To chide; to check a dog by the voice: Hæsa, *Saxon*, mandatum.
"Haze, perterrifacio."—Ainsworth's *Dictionary*.

HEATHER. The top-binding of a hedge: Heder, *Saxon*.
"In lopping and felling save edder and stake,
Thine hedges, as needeth, to mend, or to make."— Thomas Tusser,
Five Hundred Points of Good Husbandry, January 13.

HEEL—of the hand. The part above the wrist, opposite the thumb.

HEFT. Subst, Weight, burden; Verb, To weigh: Hœftan, *Saxon*.

HELE. To cover: Helan, *Saxon*.
"Pardé we women connen nothing hele,
Witness on Midas."—Chaucer, *Wife of Bathes Tale*, 1. 94.

HELIAR. A thatcher.

HIC-WALL The green woodpecker: Name derived from his cry.
"The crow is digging at his breast amain,
The sharp-nebbed hecco stabbing at his brain."— Michael Drayton.
"And this same herb your hickways, alias woodpeckers, use."—Ozell's
Rabelais, iv. 62.

HIGHST. To uplift; to hoist.

HILLARD, HILLWARD. Towards the hill or high country.

HILT, see Yelt.

HINGE. The liver, lungs, and heart of a sheep, hanging to the head by the
windpipe: Hangan, *Saxon*.

HIVE. To cherish; to cover as a hen her chickens: Hife, *Saxon*.
"And sesith on her sete, with her softe plumes,
And hoveth the eyren."—Deposition of King Richard II.

HOG. A sheep of either sex, one year old: Owca, a sheep, *Polish*(?) Og,
young; *Gaelic*(?)

HOLT. A high wood: Holt, *Saxon*.
"The fawkon and the fessaunt both
Among the holtes on hee."—*Battle of Otterbourne*, Percy's *Reliques*.
"Makyne went hameward blyth enough
Out owre the holtis hair."—Ditto.
"Whan Zephirus eke with his sote brethe
Enspired hath in every holte and hethe
The tendre croppes."—Chaucer, *Prologue, Canterbury Tales*, 1. 5.

HOOP. The bullfinch: So called from the white mark on his neck.

HOPE. A hill.

HOUSEN. Plural of houses.

HOX. To cut in an unseemly manner: From the ancient practice of houghing cattle; sometimes, mankind.

HUT, or HOT. Past tense of To hit.
"A viper, smitten or hot with a reed, is astonied."—Scott's *Discovery of Witchcraft*, 5, 8.

I.

INGLE* Fondling; favourite; Verb, To fondle, to cherish, to love: Ing, *Saxon*, patronymic; also diminutive, used affectionately.
"Well, Tom, give me thy fist, we are friends, you shall be mine ingle, I love you."—John Ford, *Witch of Edmonton*, act iii. sc. 2.
"And kissed, and ingled on thy father's knee."— John Donne, *Elegies*, iv.

ININ, or INNION. The onion.

INNARDS, INWARDS. The intestines: Innode, *Saxon*.

INTO. Used frequently for "except," as "All gone into one": Even to, contracted to "E'en to."

J.

JARL, pronounced "YARL." The title Earl: Jarl, *Norwegian*.

JETTY. To protrude; to thrust out: Jut.
"O'erhang and jetty."—Shakespeare, *Henry IV*, act iii. sc. 1.

JIGGER. To put out of joint; as, "I'll jigger thee neck."

JOGGET. A small load of hay.

JOMETTRY. Spoken of anything self-supported in an unknown manner:

* The exact meaning of this word has been misunderstood by Burns, and he has been followed by Sir Walter Scott, in the interpretation given to the word "Ingle-nook." Both these eminent poets consider "Ingle-nook" to mean the fire-place, the hearth-stone; it really means that seat which in wide ancient chimneys is frequently found built on either side the fire, and within the arch of the fire-place itself, often called also the "Sluggard's corner." This, as the warmest seat in the hall, was given to the most delicate and favoured of the children, and hence was called "the Ingle-nook." See also Nares's *Glossary* on this word, where the meaning, as we have stated it, is clearly maintained, together with an undoubted, but most unhappy, extension of it.

JOGGET. A small load of hay.

JOMETTRY. Spoken of anything self-supported in an unknown manner: Geometry.

"It hangs by Jomettry."—Common phrase; geometry being considered as magic.

JOWL. The jaw-bone: Chaule or chaw, which see.

"Of an ass he caught the chaule-bone."—Baker, 33.

"Pigs' chauls are to be had at every pork-shop."—See Nares's *Glossary*.

JUNKETS. Sweetmeats, dainties.

"You know, there wants no junkets at the feast,"—Shakespeare, *The Taming of the Shrew*, act iii. end.

K .

KALLENGE. Challenge; so pronounced.

KECK. To heave at the stomach: Kecken, *Dutch*.

"Therefore patients must not keck at them at first."—Francis Bacon's *Natural History*.

"The faction is it not notorious?

Agricultural Parishioner (wishing to ingratiate himself with the new curate, who had given a lecture on the previous evening). Thank ye, sir, for your reading to us last night." *New curate.* "Glad you liked it, John. I was a little afraid lest the lecture might have been just a *little* too scientific." *Agricultural Parishioner.* "No, bless you, sir, not a bit of it. Why, we in these parts be just like young ducks, *we do gobble up anything!*"

Keck at the memory of the glorious."—Jonathan Swift.

KEECH. A lump of fat, congealed after melting.
"Thou obscene, greasy tallow keech."—Shakespeare, *Henry IV*, Part I.
act ii. sc. 4.
"I wonder, That such a keech can with his very bulk
Take up the rays of the beneficial sun."—*Henry VIII*, act i. sc. 1.

KEER LUCKS. Look here; so spoken.

KERFE. A cutting from a hayrick: Ceorfau, *Saxon.*

KINCH. The young fry of fish: Kunch-ike, a fish, *Sanscrit?*

KIND. Promising well, prosperous, healthy: Cynne, *Saxon.*
"The asp is kind," "the tree grows kind," "the sow looks kind."—
Common phrases.

KING-CROWN. The wild guelder rose, viburnium opulus: The flower
formerly used wherewith to crown the king of May.

KITTLE. Anything requiring nice management: Kitselen, *Teutonic.*

L.

LAGGER. A long strip of land: Laggs, long, *Gothic.*

LAIKING. Idling, playing truant: Quasi, lacking service, masterless.
"And if hym list for to laike,
Thenne loke we mowen."—William Langland, *Vision of Piers
Plowman*, 1. 341.

LAMB. To beat: Perhaps the same as "lame,"but it is popularly derived
from the murder of Dr. Lamb by the London mob, *temp.* Charles I.

LANDAM. To abuse with rancour: Damn through the land.
"Would I knew the villain,
I would land-damn him."—Shakespeare, *Winter's Tale*, act ii. sc. i.

LARROP. To beat, to flog: Said to be a sea term from "lee" and "rope,"
because the culprit goes to leeward to be flogged?

LATTERMATH. Grass after mowing: see Atter-math.

LAYTER. The full amount of eggs laid by a bird.

LEE, LEW. Shelter from wind or rain: Hle, Hlie, *Icelandic.*

LEECH. A cow doctor: Lece, *Saxon.*
Used for a physician by old writers, *passim.*

LEER. Empty, hungry: Ge-lear, *Saxon*.
"But at the first encounter down he lay,
The horse ran leere away without the man."—John Harrington's
Ariosto, xxiv. 64.

LEESE. To glean corn: Lesan, *Saxon*.
"Mai I no longere lyve with my leesinge."—Song of the Husbandman,
Political Songs, *temp*. Edward I.
"She in harvest used to leese,
But, harvest done, to chare-work did aspire."—Dryden.

LENNER, LENOW. To soften, to assuage: Lenis, Lenior *Latin(?)*

LIBBET. A shred, a tatter: Perhaps from the old word "lib" to emasculate.
Shakespeare writes it "glib."
"I'm libbed in the breech already."—Philip Massinger, *Renegado*, act ii.sc.2.
"They are co-heirs,
And I had rather glib myself than they
Should not produce fair issues."—Shakespeare, *Winter's Tale*, act ii. sc. 1.

LIFF, LIEVER. Rather, more inclined to: Leof, *Saxon*.

LIGHTING-STOCK. Steps to facilitate ascent or descent when riding.

LIKE. A frequent pleonasm, as "dead-like," "pretty-like," etc.: Lich, *Saxon*.

LILL. Spoken of the tongue of a dog dropping his saliva.
"And lilled forth his bloody tongue."—Edmund Spenser's *Fairy Queen*,
i. 32.

LIMBER. Weak, pliant, flagging: Lim, *Saxon*.
"Those waved their limber fans
For wings."—John Milton.
"You put me off with limber vows,"—Shakespeare, *Winter's Tale*, act
i. sc. 2.
"Limberham," one of Dryden's comic characters; a weak person.

LIMP. Flabby, flexible: Lim, *Saxon*.
"The chub eats waterish; and the flesh of him is not firm, but limp and
tasteless." Isaac Walton.

LINCH. A small precipice, usually covered with grass: Hlinc, *Saxon*.

LINNET. Flax dressed, but not twisted into thread: Linet, *Saxon*.

LISSOME. Active, nimble: Lightsome.

LITHER. Light, active, sinewy: Lith, *Saxon*.
"Two Talbots, winged through the lither sky,

In thy despite shall 'scape mortality."—Shakespeare, *Henry VI*, Part I.,
act iv. sc. 7.
"I'll bring thy lither legs in better frame."—Anthony Wadson, *Look
about you*, 1600.

LIZZEN. A chasm in a rock: Loosen?

LIZZORY, LEZZORY. The Service tree.

LOATH. Unwilling; *also* verb, To abhor.
 "Egypt shall lothe to drink of the river,"—*Exodus*, vii. 18.
 "Ye shall lothe yourselves for your iniquities."—*Ezekiel*, xxx. 3, and *passim*.

LOP. To cut growing wood: Lup, *Sanscrit?*
 "Behold, the Lord shall lop the bough."—*Isaiah*, x. 33.

LUG. A measure of land, a perch; also a long pole.
 "And eke that ample pit, yet far renowned
 For the large leap which Debon did compel
 Coulin to make—being eight lugs of ground."—Edmund Spenser's
 Fairy Queen, ii. x. 11.

LUSH. Abundant, flourishing.
 "How lush and lusty the grass looks."—Shakespeare, *Tempest*, act ii. sc. 1.

LUSTY. Strong, in full health: Lust, *Saxon*.
 "Where barley ye sow, after rye, or else wheat,
 If the land be un-lusty the crop is not great."— Thomas Tusser, *Five
 Hundred Points of Good Husbandry*, October, 24.

M.

MAIN, AMAIN, MAINLY. In an excessive degree: Magn, *Icelandic*.

MAKE. Mate, companion, lover: Maca, *Saxon*.
 "There's no goose so grey in the lake,
 That cannot find a gander for her make."—John Lyly's *Mother
 Bombie*, iii. 4.
 "This is no season
 To seek new makes in."—Ben Jonson, *Tale of a Tub*, act i. sc. 1.
 "The maids and their makes,
 At dances and wakes."—Ben Jonson, *Masque of Owls*.

MAMMOCK. Subst., A shred, a tatter; verb, To tear in pieces.
 "He did so set his teeth, and tear it; O, I warrant, how he mammockt
 it."—Shakespeare, *Coriolanus*, act i. sc. 3.

MAUNDER. To ramble in mind, to speak uncertainly, to mutter, to grumble: Maudire, *French*.

"My neighbour justice maunders at me."—Beaumont and Fletcher, *Rule a Wife*, act iii. sc. 1.

"He made me many visits, maundering, as if I had done him an injury, in having such an opening."—Wiseman's *Surgery*.

MAZZARDS. Wild cherries: Perhaps from their resemblance in shape to the skull; in which latter sense the word is used by Shakespeare and Butler.

"And knockt about the mazzard with a sexton's spade."—Shakespeare, *Hamlet*, act v. sc. 1.

"Where thou might'st stickle, without hazard
Of outrage to thy hide or mazzard."—Samuel Butler, *Hudibras*.

MERE. A strip of grass left as a boundary in open fields: Mear, *Saxon*.

"And Hygate made the meare thereof by west."—Spenser's *Fairy Queen*, iii. ii. 46.

"What mound, or steady mere, is offered to my sight?"

"The furious Team, that, on the Cambrian side,
Doth Shropshire, as a mear, from Hereford divide."—Drayton's *Polyolbion*, i., pp. 656 and 807.

MICHE, MYCHE, MOOCHE. To idle, to play truant; to pilfer.

"This is miching mallecho,—it means mischief."—Shakespeare, *Hamlet*, act. iii. sc. ii.

"Shall the blessed sun of heaven prove a micher, and eat blackberries?"—*Henry IV.*, Part I., act ii. sc. 4.

"Sure she has some meaching rascal in her house."—Beaumont and Fletcher.

MILT. The spleen: From its resemblance to the spawn of fish (?)

MIND. To remember: Munan, *Saxon*.

'MIRE. To wonder, to admire; the first syllable cut off: Admiror, *Latin*.

MIRKSHET. Twilight: Mirce, *Saxon*.

"Ere twice, in merk and occidental damp,
Moist Hesperus hath quencht his sleepy lamp."—Shakespeare, *All's Well*, &c, act ii. sc. 1.

MOIL, MYLE. To labour, to toil, to defile by labour.

The well known anagram on the name of Sir William Noy, Attorney General to King Charles I, is an example of this word, "I moyl in law."

MOOR. A marsh: Moor, *Teuton*.

"No, Caesar; they be pathless, moorish minds,
That being once made rotten with the dung
Of damned riches, ever after sink." Ben Jonson.
"Along the moorish fens
Sighs the sad genius of the coming storm."—James Thomson, *The Seasons: Winter.*

MOOR-HEN. The water-hen, the gallinull.

MORE. The roots of a plant: Moran, *Saxon.*
"Ten thousand mores of sundry scent and hew."—Spenser.

MORING-AXE. A pick-axe.

MORT. A vast quantity: Mors, death, *Latin*; as enough to kill one; or Morgt, *Icelandic.*
"Here's a mort of merry making, eh?"—Sheridan, *The Rivals*, act i. sc. 1.
"Nobody knows what a mort of fine things he used to say to me."—Hannah Cowley, *The Belle's Stratagem*, act iii. sc. 1.

MORTAL. Excessively, extremely.

MOTHERING-SUNDAY. Midlent Sunday: when cakes were presented to children or friends.
"I'll to thee a simnell bring
'Gainst thou goest a mothering."—Robert Herrick.

MOUND. A fence, a boundary: Mund, *Saxon.*
"No cold shall hinder me, with horns and hounds'
To thrid the thickets, or to leap the mounds."—Dryden.

MUN. An affirmative interjection, probably Man: Mon, *Saxon.*
"*Jacob.*—But the best fun is to come, mun!
Vane.—Now to the point (*aside*)—Is your lady married?.
Jacob.—Noa; but she's as good; and what's think, mun? To a lord's zun!"—Susannah Centlivre, *Chapter of Accidents*, act ii. sc. 2.
"Is it not pure? 'Tis better than lavender, mun!"—Congreve, *Love for Love*, act ii. sc. 10.

MUST. The crushed apples or pears, when the juice is pressed out for cyder or perry: Mustum, *Latin.*

N.

NAGGLE, NIGGLE. To tease, to fret; to nibble with the teeth: Nægel, a nail, *Saxon.*

NALE. An ale-house: Æle, *Saxon*.

NARON. None: Never, ne'er a one.

NATION. Very.
"Nation vine weyther."—Common phrase.

NEIVE. The hand: Naeve, *Danish*.
"I wu'-not, my good twopenny rascal, reach me thy neuf."—Ben
Jonson, *Poetaster*, act iii. sc. 4.
"Give me thy neefe, Monsieur Mustard-seed."—Shakespeare,
Midsummer Night's Dream, act iv. sc. 1.

NESH. Weak, tender: Nesc, *Saxon*.
"Oure nesch and hard heifore, and did the Welsh-men daie."—Peter
Langtoft, p. 242. Hearne's edition.
"For love his harte is tendre and nesche."—Chaucer, *Court of Love*.
"The darker fir, light ash, and the nesh tops of the young hazel
join."—William Crowe, *Lewesdon Hill*, v. 31.

NOT, NOTTED. Applied to cattle without horns: because in such cases the
brow is thickly knotted with hair.

NUNCHEON. Vulgarly, luncheon: Noon-chine. Some derive it from "noon-
shun," as if to refresh while avoiding the heat of midday.
"With cheese and butter-cakes enow,
On sheaves of corn were at their nunshons close."—William Brown,
Britannia's Pastorals, p. 2, v. 8.
"Laying by their swords and truncheons,
They took their breakfasts and their nuncheons."—Samuel Butler,
Hudibras.

O.

ODDS. Any difference between two specimens or statements.

ON. The sign of the genitive case.
"One on 'em," (one of them).—Common phrase.

OODLE, HOODLE, WOOD-WAIL. The nightingale: Wald and Wala,
Saxon.
"The wood-wail sung and would not cease,
Sitting upon a spray,
Soe loud she wakened Robin Hood
In the greene wood where he lay."—Thomas Percy, *Ballads*, viii. 86.

OONT or WOONT. The mole: Wand-nurre, *Saxon*.

"She hath the ears of a want, a mole."—John Lyly, *Midas*, act v. sc. 2.

OR. Before: Ere.

"At last he drew
His sword ar he were y-wer."—Robert of Gloucester.
"Or ever your pots be made hot with thorns."—*Psalms*. lviii. 8. Prayer-
book version.
"Or ever they came at the bottom of the den."—*Daniel* vi., 24.
"And we, or ever he come near, are ready to kill him."—*Acts of
Apostles* xxiii. 15.

ORTS. Chaff, any worthless matter: Nought; the first letter struck off(?)

P.

PACE. To raise with a lever: Pesser, *French*.

PARGITER. A plasterer.

PAUNCH. Verb, *a sporting word*, To disembowel game.

"The vi. day of August was bered in Powle's Cherch-yerd on Archer,
the wych was slain at Sant James fayre, in the feld by on . . . shamfully,
for he was panchyd with ys own sword."—Machyn's Diary, 1558, p.
170.

PEASEN. The plural of pea: Pois, *French*.

"With peasen, for pottage in Lent,
Thou sparest both oatmeal and bread to be spent."—Thomas Tusser,
Five Hundred Points of Good Husbandry, March, 26.
"Count peason or brank as a comfort to land."—Thomas Tusser, *Five
Hundred Points of Good Husbandry*, October, 20.

PECK. To fall forward with the motion of a bird pecking *also*, to fling
away—in the latter sense, see Example.

"You i' th' camblet, get up o' the rail, I'll peck you o'er the pale
else."—Shakespeare, *Henry VIII*, act v. sc. 5.

PELT. To throw stones or other missiles. FULL PELT, To run with speed
and force *metaphor*,—from a shower of stones.

PICK. A hay fork: Pike, Puc, *Saxon*. Acicula(?)

PIDDLE. To trifle, to do light work.

"I am now going to a party of quadrille, only to piddle at a little of it at
two poor guineas a fish."—George Farquhar, *Journey to London*,

act i. sc. 1.

"From slashing Bentley down to piddling Tibbalds."—Alexander Pope.

"Piddling at a mushroom, or the haunch of a frog."—*Guardian* No. 34.

"He recommended that we should begin piddling with a quart o claret a day."—Sir Walter Scott, *Rob Roy*.

PILL. The pool caused by the junction of two streams: Pil, *Welsh*.

PIP. Verb. To break the egg in hatching; also the first bursting of a flower pod: Peep.

PIRGY. Quarrelsome, cross-grained in temper: Burgh, *Saxon*, any place strengthened for opposition.

PITCH. To fall down heavily; also to cast away a burden, as "pitching" or loading hay into a wagon.

"And tho he was y-flowe an hey, and ne cowthe not a ligte

A doun mid so gret eir to the erthe he fel and pigte."—Robert of Gloucester, p. 29.

"Forward he flew, and pitching on his head,

He quivered with his feet and lay for dead."—Dryden.

PITH, PETH. The crumb of bread; the formation in the cavity of the elder tree: Pitha, *Saxon*.

PLASH. A small pool: Plasche, *Teuton*.

"For I have Pisa left,

And am to Padua come; as he that leaves

A shallow plash to plunge him in the deep."—Shakespeare, *Taming the Shrew*, act i. sc. 1.

PLEACH. To lay a hedge; to intertwine the branches of pollards for shading a walk.

PLIM. To swell with moisture: Plyme, prunum, *Saxon*? (Metaphorically used to express any swelling containing moisture).

"The bacon plims in the pot."—Francis Grose, *Dictionary of the Vulgar Tongue*.

PLY. To bend; Subst. A bending, a turn.

"I think not Prince Charles safe in Jersey. In God's name let him stay with thee, till it is seen what ply my business will take."—King Charles I to his Queen; letter dated Newcastle, May 28, 1646.

POLLARDS or POLTS. A mixed crop of peas and beans: Bol, *Dutch*, a bean, or peul, a chick-pea.

"White pollard or red, that so richly is set,

For land that is heavy, is best ye can get."—Thomas Tusser, *Five Hundred Points of Good Husbandry*, October, 16.

POSSY. A great number: The sheriff's posse comitatus.

POTCH. To poke with the finger, or any blunt instrument.

POVEY. An owl; From the appearance of the bird, "puffy."

POWER. Any vast accumulation.

POZY. A bunch of flowers, a nosegay: such nosegays were formerly presented to ladies with laudatory poesies.
"Be merry
And drink sherry that's my posie."—Ben Jonson, *New Inn*.

PRIZE. Verb, To weigh: Priser, *French*, to appraise, to value.

PRONG. A large hay-fork: Prion, *Icelandic*.
"Be mindful
With iron teeth of prongs to move
The crusted earth."—John Dryden, *Virgil*.
"High o'er the hearth a chine of bacon hung;
Good old Philemon seized it with a prong."— John Dryden, *Baucis and Philemon*.

PUCK. A quantity of sheaves stacked together: Poke, pocket.

PUCK-FOUST. A fungus, the puff-ball: Puck, the fairy and fust.

PUCK-LEDDEN. Deceived, betrayed by false ideas; Led by Puck, the fairy.

PUE. The udder of a cow: Piw, *Welsh*, a dug.

PURE. In good health, or with good success.

PURL. To throw with violence. Quasi, hurl?

Q.

QUAR. A stone quarry: Carriere, *French*.
"The stwons that bwilt Gearge Bidler's oven,
And thay did cwome vrom Blakeney's Quarr."—Old Song in Gloucestershire. See also Drayton.
"Cut from the quar
Of Machiavel, a true cornelian."—Ben Jonson, *Magnetic Lady*, act i. sc. 7.

QUARREL. A square pane of glass: Carreau, *French*.
"A lozenge is a most beautiful figure being in his kind a quadrangle

reverst,with his point upwards, like a quarrel of glass."—George Puttenham, *Book II*, ch. 11.

QUICK, QUICKSET. Young white-thorn for hedges: Derived from rapidity of growth.

QUILT. To swallow, to gulp, to catch breath by swallowing: derived from the sound.

"How now, blown, Jack ? How now, quilt?"—Shakespeare, *Henry IV*, Part I, act iv. sc. 2.

"He sat with me while I had quilted two pigeons, very handsome and good meat."—Samuel Pepys, *Diary*, Sept. 26, 1668.

QUIST. A wood-pigeon: Cuseote, *Saxon*.

QUITCH, SQUITCH. Couch-grass: Cwice, *Saxon*.

QUOB, QUOP. To tremble, to quail, to beat strongly at the heart.

"His hearte began to quappe,

Hearing her come."—Chaucer.

"My heart 'gan quop full oft."—Chaucer, *Ordinary* II. 2.

"But, zealous sir, what say you to a touch at praier?

How quops the spirit ?"—John Fletcher, *Poems*, p. 203.

QUOMP. To subdue: Cwealm, *Saxon*.

R.

RACK. A path, chiefly applied to paths mades by hares: Ralka, cursitare, *Swedish*; or racke, a track, *Dutch*.

RAG. To chide, to abuse: Wregan, *Saxon*.

"I ragged him for it."—Samauel Pegge, *Anecdotes of the English Language*.

RAMES. Dead stalks; *also* a skeleton.

RAMSHACKLE. To move, with noise, in a loose, disjointed manner: Ram in shackles.

"He came in ram-shackle fashion."—Common phrase.

RAMSONS. Broad-leaved garlic, allium ursinum.

"The third sort of garlic, called ramsons, hath mostly two brode blades or leaves."—Lyte, *Dodoeus*, p. 734.

RANGLE. To entwine, to embarrass as woodbine: Wrangle, to argue, metaphorically used.

RASSLE. To run at the roots, and thus to form new plants: Quasi, wrestle.

RATH. Early, quick, rash: Hræth, *Saxon*.

RAUGHT. The past tense of Reach: Rœhte, *Saxon*.
"That with his grene top the heven raught."—Chaucer, *The Knights'
Tale*, 1. 2917.
"The moon was a month old when Adam was no more,
And raught not to five weeks when he came to five score."—
Shakespeare, *Love's Labour's Lost*, act iii. sc. 2.
"This staff of honour raught, there let it stand,
Where best it fits to be.— in Henry's hand."—Shakespeare *Henry IV*,
Part II., act ii. sc. 3.
"The English, then supposed to be alone, came in presence of the
enemie before that intelligence rought him."—*Autobiography of King
James II*, Vol. ii. p. 493, fol. ed.

RAVES. The rails which surround the bed of a waggon.

RAVELMENT. Entanglement.

REED. Counsel: Rœd, *Saxon*.
"He could no better rede."—Chaucer, *Monk's Tale*.
"Himself the primrose-path of dalliance treads,
And recks not his own rede."—Shakespeare, *Hamlet*, act i. sc. 3.

REEN. A small stream: Rhin, *Welsh*.

REERMOUSE. The bat: Hrere-mus, *Saxon*.
"Some war with rear-mice for their leathern wings."—Shakespeare,
Midsummer Night's Dream, act ii. sc. 3.
"Once a bat, and ever a bat, a reremouse and bird of twilight."—Ben
Jonson, *New Inn*, act iii. sc. 1.
"Sir, I keep no shades
Nor shelters, I, for either owls or rere-mice."—Ibid., act i. sc. 2.

RENEAGE. To renounce, to deny; but chiefly, to decline to follow suit at
cards: Renier, *French*.
"His captain's heart,
Which in the scuffles of great fights hath burst
The buckles on his breast, reneges all temper."—Shakespeare, *Anthony
and Cleopatra*, act. i. sc. I.

RETCH. To strain before sickness: Hrœcan, *Saxon*.

RIDE. A rootstock in coppice: Wriden, *Saxon*, germinare.

RIME. Hoar-frost: Rim-frost, *Saxon*.
"In rime-frosts you shall find drops of dew upon the inside of glass

windows."—Francis Bacon.

RINCE, RINCE OUT. To cleanse; applied chiefly to washing drinking
glasses: Hrains, *Goth.*, to cleanse.

"This last costly treaty

Swallowed so much treasure, and, like a glass,

Did break in the rinsing."—Shakespeare.

"They cannot boil, nor wash, nor rinse, they say."—King. Quoted by

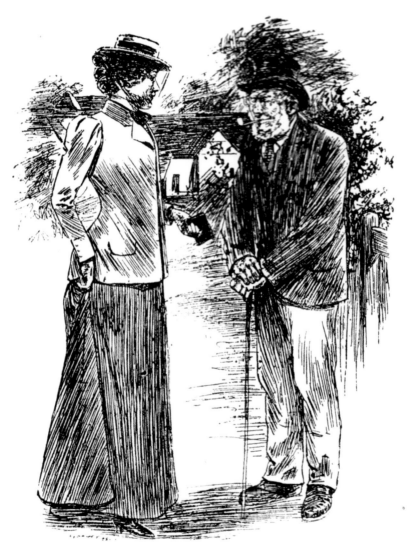

The Vicar's Daughter. "Papa was very shocked, Giles, to see you standing outside the 'Green
Man' this morning, after church."
The Village Reprobate. "Oi can 'sure ye, miss, it wus na fault o' moine that I wus standin'
ootside!"

Thomas Tegg, *The London Encyclopedia, or Universal Dictionary of Science*, 1829.

RIVE. To split asunder.
"I was about to tell thee, when my heart,
As wedged with a sigh, would rive in twain."—Shakespeare, *Troilus and Cressida*, act i. sc. 1.

ROLLERS. Hay rolled together preparatory to loading.

RONGS. Steps in a ladder: Hrugg, *Goth*. idem. This word is used for staves in Joseph Ritson's *Ancient Ballads*.

ROUND, RUNE. Verb, To whisper: Runian, *Saxon*.
"What rownest thou with our maide? Benedicite!"—Chaucer, *Wife of Bath's* Prologue.
"They're here with me already; whispering, rounding,
'Sicilia is a so-forth.'"—Shakespeare, *Winter's Tale*, act i. sc. 1.

ROUNDS. An accustomed circuit.
"Edward, with horror and alarm, beheld the animal making his rounds."—Sir Walter Scott, *Waverley*, ch. xi.

ROVE. The past tense of Rive; *also* to wander.

RUCK. A crease in a garment, any accumulation: Hric, *Saxon*.

RUGGLE. Verb, to struggle; subst. A child's rattle, a bell for sheep: Hrug, *Saxon*, asper.

RUMPLE. To discompose linen, bedding, wearing apparel, etc.

RUSTY, REASTY. Spoken of rancid bacon, or salt meat.
"Through folly too beastly
Much bacon is reasty."—Thomas Tusser, *Five Hundred Points of Good Husbandry*, November.

S.

SCANTLINGS. The slabs or outsides of a tree, when sawn into boards.

SCATHE, SCĒĀTH. Damage: Sceathe, *Saxon*.
"But she was some-dele defe, and that was scathe."—Chaucer, *Canterbury Tales*, Prologue, 1. 448.
"Of scathe I will me skere.—*Political Songs*, *temp*. Edward I. "To do offence, or scathe, in Christendom."—Shakespeare, *King John*, act ii. sc. 1.

SCORT. The foot-marks of horses, cattle, or deer; *also* the drag on a wheel;

because it scores the road: Quasi, scored, or scaera, *Suio-Gothic*, incidere.

SCREECH. A bird, the swift: from its cry when on the wing.

SCREECH-DROSSLE. The missel-thrush: Drossel, *German*, and screech, its cry when alarmed.

SCRUB. Shrub: Scrob, *Saxon*.

SCRUSE, SCRUZ. The past tense of Squeeze.
"And having scruz out of his carrion corse
The hateful life."—Spenser, Fairy Queen.

SCUBBIN. The fore quarter of a lamb without the shoulder.

SEEDS. A clover lay.

SEG. *A clothier's word*—Urine used in their fabrics: Sege, *Saxon*, Casus?

SEGS, ZEGS. Sedges, the water plant: Secge, *Saxon*.
"Segs, and bulrush, and the shepherd's reed."—Michael Drayton,
Moses his Birth and Miracles, p. 1582.
"I've wove a coffin, for his corse of segs,
That with the wind did wave like bannerets."—Robert Garnier,
translated by Thomas Kyd, *Cornelia*, Old Plays ii. 266.

SEWENT. Successive, applied to a continuous rain: Sew, to follow,
Cornish(?) The law word, To sue.
"And heo of Troy siwede without eny feyntyse."—Robert of
Gloucester, p. 20.

SHARD. A breach in a fence.
"And often to our comfort we shall find
The sharded beetle in a safer hold
Than is the full-winged eagle."—Shakespeare, *Cymbeline*, act iii. sc. 3.

SHATTERS. Fragments of broken pottery, glass, or other hard but fragile
substances.

SHIDE. A small plank, a piece of wood split off from timber: Scide, *Saxon*.
Frequent in Sibbald's *Collection of Old Ballads*.

SHORE UP. To prop with timber.
"They undermined the wall, and, as they wrought, shored it up with
timber."—Knowles.

SHOT, SHOT OF. To be rid of; Shittan, *Saxon*, to cast down or away.
"I am well shot of it."—Common phrase.

SHRIM. To shiver, to shrink up with cold or terror. Scrimman, *Saxon*.

SHROUD. To lop a pollard tree. Screadan, *Saxon*.

SIGHT. A vast number.
"A sight of blind volk."—Cotswold phrase.
"A sight of flambeaux, and a noise of fiddles."—Thomas Shadwell,
The Scowrers, act, v. sc. 1.

SKAG. A rent; *also* a branch not primed close to the tree.

SKALE. A skimming dish: Schale, idem, *Longobardic*.

SKELM. A long pole.

SKID. A drag to a carriage, the shoe under the wheel: Skid, idem. *Icelandic*.

SKĪŪL, SKEEL. A shallow tub wherein to cool beer: Quasi, Schale as above?

SKILLING. A cow-shed: Skiul, idem, *Swedish*.

SKRIKE. To shriek: Skrika, idem, *Swedish*.

SKURRY. A flock in confused flight: Skare, *Icelandic*, whence Scare, to alarm.

SKRAWL, SCRAWLING FROST. The slight frost which scrawls the earth
 in rectangular lines.

SLABS. The outsides of a tree when sawn into boards.

SLAM. To beat; especially to shut the door with violence: Slaemra,
 Icelandic.

SLAMMERKIN. A slut: Schlamm, dirt, *German*.

SLAT. Used for "slit" to split, to separate, to crack.

SLEIGHTS. Down-land, grass kept solely for pasture: Slighted.

SLEEZE. *A clothier's word*, to express the separation of texture in a badly
 woven cloth.

SLICK. Slippery: Schlicht, *Teuton*.

SLICKUTS. Curds and whey: "Slick" and "eat?"

SLINGE. *A clothier's word*, To steal wool from the pack in small quantities
 at a time: Slincan, *Saxon*, to slink, to sneak.

SLIVER A slice of anything; used by Shakespeare as a verb: Slifan, *Saxon*.
 "When frost will not suffer to dike and to hedge,
 Then get thee a heat with thy beetle and wedge:
 Once Hallowmas come, and a fire in the hall,
 Such slivers do well for to lie by the wall."—Thomas Tusser, *Five
 Hundred Points of Good Husbandry*, December, 1.
 "Slips of yew

Slivered in the moon's eclipse."—Shakespeare, *Macbeth*, act iv. sc. 1.
"She that herself will sliver and disbranch
From her maternal sap, perforce must wither."—Shakespeare, *King Lear*, act iv. sc. 2.

SMACK. A blow with the open hand producing a noise, an audible kiss: Smitan, *Saxon*.

SNEAD, SNED. The handle of a scythe: Snæd, *Saxon*.
"This is fixed on a long snead or straight handle, and doth wonderfully expedite the trimming of hedges."—John Evelyn, *Silva*, xiii. 2.

SNITE. To blow the nose. Snytan, *Saxon*.
"So looks he like a marble towards raine;
And wrings, and snites, and weeps, and wipes again." —Joseph Hall, *Satires*, vi. 1.

SNOUL. A lump, particularly of bread, cheese, or the like: Snidan, *Saxon*, amputare, suars.

SNUGGLE. To lie close together, as children: Snug.

SOLID. Steady, continuous progress: Solidus, *Latin*.
"To go solid," "a solid rain."—Cotswold phrases.

SPAR. A wooden bolt: Sparrian, *Saxon*.
"I've heard you offered, sir, to lock up smoke,
And calk your windows, spar up all your doors."—Ben Jonson, *Staple of News*, act ii.
"And the gates after them speed."—Robert of Brunne.
"And rent adown both wall, and sparre, and rafter."—Chaucer, *Knight's Tale*, 1. 132.

SPAUL. The broad wound in a timber tree by rending off a considerable branch: Spia ell, segmentum, *Icelandic*.

SPAY-SPEED. Humour discharged from the eyes: "Speed," as proceeding from, and "spay" to geld, to render unfruitful?

SPEAR. Often used to denote a rapier, a sword-stick or spit: Ysbur, a spit, *Welsh?*

SPEW. A spungy piece of ground.

SPIT. A spade: rapid pronunciation.

SPRACK. Lively, vigorous: Spraeg, famosus, *Swedish*.
"He is a good sprag memory."—Shakespeare, *Merry Wives of Windsor*, act iv. sc. 1. Here Evans uses the g for ck, as in "hig, hæg, hog," which is his Welsh pronunciation for "hic, hæc, hoc." The ancient use of the

word "sprack" is seen in the sobriquet given to Thorgil, King of Sweden, *circa*, 960, viz., "Thorgil-sprack-a-leg" i.e., Thorgil the "nimble," or "with the handsome leg:" probably both meanings were applicable.

SPREATHE. To have the face or hands roughened by frost.

SPURTLE. To sprinkle with any liquid.

SQUAIL. To pelt with stones or sticks: *Hebrew*

SQUASH, SQUICH. The crushing any moist or tender body by a fall or blow.

SQUISH-QUASH. The walking through mud or shallow water.

SQUAT. Verb, To sit close, as a hare; subst., a bruise or indentation.
"Him they found,
Squat like a toad close at the ear of Eve."—John Milton.
"Bruises, squats, and falls, which often kill others, hurt not the temperate."—Herbert

STAG, STĀĒG. A young ox.

STANK. A pool caused by a dam on a stream; also the dam itself: Stanc, *Welsh*, idem.
"Thei lighted and abided biside a water-stank."—Peter Langtoft.

STEER. A heifer: Stire, *Saxon*, vitulus.

STIVE, STIVE UP. To stifle with heat.

STOGGLE. A pollard tree: stock.

STORM-COCK. The missel thrush: because he sings with more power in stormy weather.

STOWL, STOOL. The stump left in coppice-wood after the cutting.

STRAIGHTWAYS. Immediately.

SWAG, SWAGGLE. To sway to and fro: Swegia, *Icelandic*, idem.
"The motion of the moon swaggles the whole water of the sea, and, as it returns back again westward, brings all the whole sea, with a swaggle, back to landward upon us."—John Butler, *Hagiastrologia*, 1680, p. 45.

SWALE. To waste away, as a lighted candle in the wind; *also* to singe: Swelan, *Saxon*.
"But dashed with rain from eyes, and swailed with sighs, burn dim."—William Congreve, *The Way of the World*.
"Into his face the brond he forst, his huge beard brent, and swailing made a stink."—Phaer.

SWELTER. To faint with heat, to sweat: Sweltan, *Saxon*.
"If the sun's excessive heat
Makes our bodies swelter."—John Chalkhill.

SWICH. Such.
"Suich Giffarde's asoyne, icholde hom ofte come."—Robert of
Gloucester, vol. II., p. 539.
"Suich was the morthre of Eivesham vor bataile it nas non." p. 560.
"For unto swiche a worthy man as he Accordeth nought."—Chaucer,
Canterbury Tales, Prologue, 1. 243, 247, 487. *Et passim*.

SWIG. To drink fully, to drain the cup: Swiga, *Icelandic*, idem.
"The lambkins swig the teat,
And find no moisture."—Creech.

SWILL. To wash away: Swelan, *Saxon*.
"As fearfully as does the galled rock
O'erhang and jetty his confounded base,
Swilled with the wild and wasteful ocean."—Shakespeare, *Henry V*,
act iii. sc. I.

SWOP. To barter, to exchange: Suaip, *Gaelic*, idem.
"I would have swopped youth for old age, and all my life behind, to
have been then a momentary man."—Dryden.

T.

TABLING. The coping on a wall or gable.

TACK. Grazing for cattle through the summer.

TALLOW. Concrete stalactite found in oolitic rocks: from the appearance.

TALLUT. The hayloft.
"Thayloft—Thalloft—Thallet—Tallut."—Cotswold contractions.

TED. To spread abroad new-mown grass for hay: Teadan, *Saxon*.
"The smell of grain, or tedded grass, or kine."—Milton.
"Go, sirs, and away,
To ted and make hay." —Thomas Tusser, *Five Hundred Points of
Good Husbandry*, July's Abstract.

TEEM. To empty; spoken of a tub.

TEG. A lamb, one year old: Tyccen, *Saxon*.

TERRIFY. To annoy, to vex, to harass.

TESTER. A sixpence; so named from the royal head on it: Teste, *Old French*.
"Well, said I, Wart, thou art a good scab; hold, there's a tester for
thee."—Shakespeare, *Henry IV*, Part II., act iii. sc 2.
"Who throws away a tester and a mistress, loses a sixpence."—George
Farquhar, *Love and a Bottle*, act i. sc. 1.

THEAVE. A ewe in the second year.

THIC, THACH. This, that.

THILLER, TILLER. The shaft-horse in a waggon; Thill, *Saxon*.
"Thou hast got more hair on thy chin, than Dobbin, my thill-horse,
has on his tail."—Shakespeare, *Merchant of Venice*, act ii. sc. 2.

TICE. To entice,—a contraction.

TICKLE. Uncertain in temper, frail, shy, liable to accidents.
"Heo is tikel of hire tayl; talwys of hire tonge."—William Langland,
Vision of Piers Ploughman, Pass, iii, 1. 126.

TID. Playful, sometimes in a bad sense, mischievously frolicsome.

TIDDLE. To rear up delicately: Tydd, *Saxon*, id.

TIDY. Neat; *also*, as a result of neatness, frugal.

TILE OPEN. To set open a gate; properly, to fix it open with a stone:
because the stone fittest for the purpose is thin, like a tile.

TILT, TILT OVER. To overthrow: a word probably from the tilt-yard.
"Alternately to dash him to the pavement, and tilt him aloft again."—
John Hill Burton, *History of Scotland*, vol. ii. p. 274.

TINE. To kindle. See "Candle-tinning."

TITTY. An epithet applied to a wren: Titje, any small bird, *Teuton*.
"And of these chanting fowls, the goldfinch not behind,
That hath so many sorts descending from her kind;
The titty for her notes as delicate as they."—Michael Drayton,
Polyolbion, xiii. p. 915.

TRIG. Neat, quick, ready: Tryg, *Danish* idem.
"You are a pimp and a trig,
An Amadis de Gaul, or a Don Quixote."—Ben Jonson, *Alchemist*,
act iv. sc. 1.

TUD. An apple dumpling.
"As round as a tud, and as slick as a oont." Spoken of a child's cheek.

TUMP. Earth thrown up: Twmp, *Welsh* idem.

"Tump, a hillock, tumulus."—Robert Ainsworth, *Dictionary*.

TUN. That part of the chimney which stands above the roof: Tunnel, a contraction.

TUSSOCK. A thick tuft of grass: Tusw, *Welsh*, a wisp, a bunch.

TWAITE. A fish, of the shad kind.

A DRY CALLING

Th' ole squire stop an' spoke to me this marnin'; an' Oi ast 'im ow Master Philip was gettin' on in Lunnon. 'Oh,' says 'e, 'e's bin called to the bar.' Oi dunno wot 'e meant, so Oi didn' say nothin'; but Oi says to meself. 'Ah,' Oi says, 'from what *Oi* remember of 'im, e' didn't want no *callin'*'!"

TWICHILD. The childish imbecility of age: Twice and child.

TWINK. The chaffinch: Winc, *Welsh*; Wirike, *Austrian*, all derived from the note of the bird.

TWISSLE. To turn about rapidly.

TWITCH. To touch; the W intrusive.

TYNING. An enclosure from a common field: Tynan, *Saxon*, to lose, because the common field loses it.

U.

UNKARD, UNKET. Unknown, uncouth, lonely: Unceid, *Saxon*.

UPSHOT. The amount of a reckoning; the result of any train of circumstances.

V.

VALUE, (pronounced VALLEY). Used with much the same meaning as Upshot. "I went the vallie of foive maile."—Cotswold phrase.

VELLET or FELLET. The annual fall in coppice: To fell.

VENTERSOME. Heedless; daring.

VINNEY. Mildewed, mouldy; especially spoken of bread; Finig, *Saxon*. "Many of Chaucer's words are become, as it were, vinewed, and hoare. with over-long lying."—Francis Beaumont. Introductory letter to Thomas Speght's *Complete Workes of Chaucer*.

VLAKE. Flake. A wattled hurdle: Vlaeck, *Teuton*, id.

VOSSLE, FOSSLE. To entangle; to confuse business: Fuss; fussy(?)

W.

WAG, WAGGLE. To move; to vacillate: Wagion, *Saxon*.
"You may as well forbid the mountain pines
Wag their high tops."—Shakespeare.

WAIN-COCK. A waggon-load of hay, cocked in one mass for security against rain: Wain, an old word for waggon.

WALLOP. To beat.

WAMBLE, WABBLE. To move awkwardly, or to and fro: Wemmelen, *Dutch*.

"When your cold salads, without salt or vinegar,
Be wambling in your stomachs."—Beaumont and Fletcher.

WAP. To beat: Wapper, a whip, *Teuton*.

WAPPER. A word expressing unusual size, as being able to beat.

WAPPERED. Fatigued; beaten.
"This it is
That makes the wappered widow wed again."—Shakespeare, *Timon of Athens*, act iv. sc. 3.
"We come towards the gods,
Young, and un-wappered, not halting under crimes."—Beaumont and Fletcher, *Two Noble Kinsmen*, act v. sc. 4

WARND. To assure; to make certain: Contracted from Warrant.

WARP. To cast young prematurely; to miscarry: Werpen, *Dutch*.

WEETHY. Soft; pliant; flexible: With, the plant Vitelba.

WELT. To strengthen a door or vessel with metallic bands, usually iron.

WET. Used, as a substantive, for rain.
"Come in, out of the wet."—Cotswold phrase.

WHALE. A stripe; the mark left by the lash of a whip: Wala(?) *Saxon*.
"Thy sacred body was stripped of thy garments, and waled with bloody stripes."—Bishop Hall.

WHATTLE and DAB. A building of whattle-work and plaster.

WHEEDLE. To coax; to deceive by flatteries: Adwelian, *Saxon*.
"To learn the unlucky art of wheedling fools."—Dryden.
"They mixed threats with their wheedles."
"Some were wheedled, and others terrifyed, to fly in the face of their benefactor."—*Autobiography of King James II*, vol. ii. pp. 143 and 145.

WHELM. To overthrow: Wilma, *Icelandic*, id.; Spoken frequently of a waggon.
"They saw them whelmed, and all their confidence
Under the weight of mountains buried deep."—Milton.

WHIFFLE. To move lightly; to trifle: Gwibl, *Welsh*, id.
"Every whiffler in a laced coat, who frequents the chocolate houses, shall prate of the constitution."—Jonathan Swift.

WHIMPER. To cry; to whine as a dog.

WICKER. To neigh: Whitchelen, *Dutch*, id.

WINCH-WELL. A whirlpool: Wince, *Saxon*, id.

WINDER, WINDOR. A window: This seems to be the old derivation of the word, a door to keep out the wind. Formerly glass was a rarity, and foul weather was kept out only by the shutters.

The word spelt windore is so frequent in Butler's *Hudibras*, that it is needless to put in examples.

WILL-GILL. An effeminate person; an hermaphrodite: William and Gillian, the male and female names united.

WITE. Blame; originally, knowledge; then the guilty knowledge of a wrong: Wite, *Saxon*, idem.

"And, but I do, Sirs, let me have the wite." Chaucer, Chanon's *Yeoman's Tale*, 1. 398.

"My looser lays, I wot, doth sharply wite
For praising love."—Spenser, Fairy Queen, iv.

WIT-WALL. The large black and white woodpecker, Picus major: Perhaps from its cry, quasi, wide-wail(?)

WITH-WIND, or BETH-WIND. A creeping plant, Clematis vitalba: With-wind, *Saxon*.

WIZEN. To wither with age or disease: Wisnian, *Saxon*, id.

WOLD. Open forest-land: Wold, *Frisian*.

"St. Withold footed thrice the wold."—Shakespeare, *King Lear*, act iii. sc. 3.

"With their's do but compare the country where I lie;
My hills and 'oulds will say I am the kingdom's eye."—Michael Drayton's *Polyolbion*, xxvi.

WOMEN-VOLK. Women.

WONDERMENT, 'OONDERMENT. Anything not understood.

"When that my pen would write her titles true,
It ravished is with fancy's wonderment."—Spenser.

"Some strangers, of the wiser sort,
Made all these idle wonderments their sport."—Dryden.

WONT, see 'OONT; WONT, or 'OONT-WRIGGLE; The succession of small tumuli thrown up by the mole.

WOOD-SPITE. The green woodpecker, Picus viridis: Spect, *Danish*.

WORDLED. The Cotswold pronunciation of World.

WORSEN. To make worse.

"He might see his affairs had not suffered, or worsened there, by his acting hitherto in them."—*Autobiography of King James II*, vol. i. p. 680.

Y.

YAPPERN, Apron; YEAWS, Ewes; YARBS, Herbs; YENT, Is-not, aint;
YOUL, Howl; are a few of the very numerous instances of the erroneous
addition of the letter Y in the Cotswold dialect.

YELT, ILT, HILT. A young sow, quasi, to yield progeny: Eildan, *Saxon*.

YEMATH. Latter-grass after mowing: Ed, *Saxon*, rursus, and math.

YOPPING, YOPPETING. A dog in full cry after game, or baying a
stranger: Derived from the sound.

Z.

ZENNERS. Sinews.

ZOG. To soak.

ZWATHE. Grass when first mowed, and in rows; the field being, as it were,
swathed: Zwad, *Danish*, id.
"With tossing and raking, and setting on cocks,
Grass lately in swathes is meat for an ox."—Thomas Tusser, *Five
Hundred Points of Good Husbandry*, July, 2.
"And there the strawy Greeks, ripe for his edge,
Fall down before him, like the mower's swath."—Shakespeare, *Troilus
and Cressida*, act v. sc. 5.

Folk Phrases
of
Four Counties

Gathered from Unpublished Mss. and Oral Tadition

G. F. Northall

A blind man on a galloping horse would be glad to see it. Said to one who cavils at the smallness of a thing, or makes a fuss over some trifling defect.

A Bobby Dazzler. A resplendent fop.

A brownpaper clerk. A petty warehouseman.

A face like a wet Saturday night.

A face like the corner of a street, i.e. angular.

A face that would stop a clock, i.e. repellent.

A gardener has a big thumb nail. Manages to carry off a great deal of his master's property.

A good deal to chew but little to swallow. This was once said of shop-bread by old country people: it is now used indiscriminately.

A good man round a barrel but no cooper. Said of a noted drinker. This phrase is included in Lawson's *Upton-on-Severn words and Phrases, Dial. Soc. Publs*. It is common in Worcestershire. Another and more usual phrase is, 'A public-house would want but two customers, him and a man to fetch away the grains.'

A good old farmer's clock = a correct timepiece.

A good one to send for sorrow. Spoken of an idler.

A good wife and a good cat are best at home.

A head like a bladder of lard, i.e. bald and shiny.

A horse with its head where its tail ought to be. Tail towards the manger.

A Johnny Raw. A bumpkin, rustic. 'Johnny Whipstraw' is another term.

A juniper lecture = a reprimand.

A lick and a promise and better next time. Alluding to a hasty wash given to a child, dish, etc.

A long thing and a thank you. Said of anything lengthy not having particular value.

A lowing cow soon forgets her calf. *West Worc. Words*, by Mrs. Chamberlain, 1882. *Dial. Soc. Publs.* Compare — 'Hit nis noht al for the calf that cow louweth, Ac hit is for the grene gras that in the medewe grouweth.' — Wright's *Political Songs*, 1839, p.332.

A mere dog in a doublet = A mean pitiful creature.

A mess for a mad dog. Said of a meal or course compounded of various ingredients.

A miller is never dry. Never waits to be thirsty before drinking.

A month of Sundays. A figure for a very long time, or even eternity.

A mouth like a parish oven.

A nod's as good as a wink to a blind horse.

A poor hap'orth of cheese. *Worc.* Said of a sickly child.

A roadman's sweat is good for sore eyes.

A silver new nothing to hang on your sleeve/arm. Youngsters sometimes worry their elders with the question — 'What shall you bring me from the fair, market, or town?' This phrase is the stock answer. A *tantadlin-tart* was once a common reply.

A slice from a cut cake is never missed. This is usually said to gloss over a breach of some moral law — partictilarly the seventh commandment.

A still bee gathers no honey. *Glouc.*

A tongue banging = A scolding: some say 'tongue-walking,' others 'skull-dragging.'

A tongue like a whip-saw.

A tongue that goes nineteen to the dozen.

A wheelstring sort of job, i.e. endless. *Worcs.*

A word and a blow and the blow first. Hasty temper.

A young shaver =A sharp youth. *Common.*

About a tie. *Warw.* Said of two people whose qualities, actions, etc. are similar, or of one value.

All one can reap and run for. *Glouc.* In *Warw.* They say 'rap and ring for.' It is a phrase much used to express the total sum of money that can be accumulated in an emergency.

All on one side like a bird with one wing.

All tittery to tottery = From laughing to staggering.

All together like Brown's cows. *Glouc.*

All together like the men of Maisemore, and they went one at a time. M. is about two miles W. of Gloucester.

An afternoon farmer = A dawdling husbandman. Lawson, *Upton-on-Severn Words*, etc., 1884, p. 34.

As big as a bee's knee.

As black as a sloe — or a sweep, or my hat.

As black as thunder.

As bright as a new penny. Mr. Hazlitt, *Proverbs*, 1882, has 'As clean as a new penny.' In Warwickshire they say 'As clean as a new pin.'

As busy as a cat in a tripe shop. *Common.*

As clean as a pink.

As clear as mud. Ironical.

As clever as mad.

As cold as a frog.

As crooked as a dog's hind leg.

As sly/cunning as a fox.

As dead as a nit. *Warw.* A nit is a young louse.

As deaf as a post.

As deep as a draw-well. *Glouc.*

As drunk as a fly.

As drunk as a fiddler's bitch. *Glouc.* Forby, *Vocab. East Anglia*, 1830, pp. 26, 27, has 'tinker's bitch.'

As drunk as a fool.

As drunk as a mop. Said of a sot that cannot stand without support.

As drunk as a parson. *Warw.*

As drunk as a pig.

As easy as an old shoe. Spoken of the fit of anything.

As fat as a match with the brimstone off.

Carrier. "Try zideways, Mrs. Jones, try zideways!" *Mrs. Jones.* "Lar' bless 'ee, John, I ain't got no zideways"

As fond of a raw place as a bluebottle. Said of one always ready for a quarrel, or anxious to touch on grievances.

As full as a tick, i.e. a bed tick.

As full of megrims as a dancing bear.

As good as a puppet show. Said of anything amusing.

As good as gold. Said of one's moral worth, or a child's behaviour, etc.; never of intrinsic value.

As grey as a badger. This refers to *colour*, and truly: but some people say of one in the dumps that he or she is 'As blue as a badger.'

As handy [with some article] **as a pig with a musket.** 'Dost look as handy wi' that as a pig do wi' a musket.' — Robertson, *Gloss. co. Glouc.*, 1890. *Dial. Soc. Publs.* p.186.

As hard as a bullet.

As hard as a flint. Said of a close-fisted or hard-hearted person.

As hard as a tabber (? Tabour). *Glouc.*

As hard as iron.

As hard as old nails.

As hard as the devil's nagnails.

As hardy as a forest pig. *Glouc.*

As heavy as lead.

As hungry as a hunter.

As ill-conditioned as old Nick.

As jolly as a sandboy.

As joyful as the back of a gravestone.

As large as life and quite as natural.

As lazy as [one] can hang together. *Worc.*

As lean as a lath.

As light as a feather.

As lousy as a coot.

As lousy as a pig.

As merry as a two year old.

As merry as Momus.

As merry as Pope Joan.

As rusty/ mouldy [*sic*] as an old horseshoe. *Glouc.*

As much use of *it* as a toad has of a side pocket. *It* may mean anything unnecessary.

As mute as a mouse.

As natural as hooping to owls. 'It do come as nat'ral as hooping do to owls' — Robertson, *Gloss. Co. Glouc.*

As near as damn it.

As near as fourpence to a groat.

As near as two ha'pennies for a penny.

As neat as ninepence.

As old as Adam or Methuselah. The former refers to time or period: the latter to longevity.

As old as the hills. 'The everlasting hills.' — Genesis xlix. 26.

As pale as a parson.

As playful as a kitten.

As pleased as a jay with a bean. *Glouc.* In the vernacular, 'As plazed as a joy with a beun.' *Joy* or *joypie* = jay. Robertson, *Gloss. co. Glouc.*, 1890.

As pretty as paint. Some say 'As fresh as paint.'

As proud as a dog with two tails.

As proud as a horse with bells. *Glouc.*

As quick as thought.

As ragged as a colt.

As red as a turkeycock's jowls [wattles]. Some say a . . .

As red as Roger's nose who was christened in pump water.

As right as ninepence. Some think this should read 'nine-pins;' but *ninepence* is a sum frequently mentioned in proverbs.

As right as pie.

As right as the mail [train], i.e. as true to time.

As rough as a bear's backside.

As round shoulder'd as a grindstone.

As safe as houses. Usually spoken of an investment.

As sandy as a Tamworth pig. Spoken of a red-haired woman; and hinting that she was likely to prove concupiscent and prolific.

As savage as a tup.

As silly as a gull/goose. A gull is a young goose.

As smart as a carrot. Said of one gaily dressed.

As smart as a master sweep.

As solid as old times.

As sound as an acorn.

As sure as fate, or death. Some say 'As sure as I'm alive;' or 'As sure as you're born:' or 'As sure as you're there.'

As sure as God made little apples.

As thick as gutter mud.

As thin as a farthing rushlight.

As thin as ha'penny ale, i.e. small beer at 2*d*. per quart.

As tight as a drum.

As ugly as sin. Said of an ill-favoured individual.

Be as quick as you can, and, if you fall down, don't stop to get up. Sometimes, 'Make haste,' etc. A jocular incentive to one going on an errand etc.

Better a quick penny than a dallying shilling.

Better long little than soon nothing.

Black your behind and go naked. This is the advice given to one who complains of no change of clothing.

"Oi be eighty-foive, zur."
"Dear me! You don't look it. And how old is your wife?"
"Oh, she be eighty-foive too. But she've looked it fer the last fowrty year!"

Bread and pull it (*pullet*). Sometimes, when a man is asked what he had for dinner — when he has fasted — he replies 'Gravel Hash,' which really means a walk on the roads. Another reply is 'Chums and chair knobs.' See '*to box Harry*.'

By degrees, as lawyers go to Heaven.

Cat, you bitch, your tail's afire. The idea of a cat bearing fire in its tail is found in many folk-tales and verses. See *English Folk Rhymes*, pp. 290-291. I can find no satisfactory explanation.

Catchings, havings; slips go again. A street phrase spoken by one threatened with capture.

Chance the Ducks. *Warw.* To do a thing and 'chance the ducks' is to do it, come what may.

Choke up, chicken, more a-hatching. *Glouc.* Mr. Hazlitt, *Proverbs*, 1882, has — 'Choke up, child, the churchyard's nigh.'

Clean gone like the boy's eye, i.e. into his 'head:' he squinted.

Come, love! or Husband's Tea. It is a standard joke that women drink the first brew, and then fill the teapot with water-adding no fresh leaves. Weak tea has received the above names, therefore.

Compliments pass when beggars meet. Ironical.

Cry! You'll p . . . the less. Addressed usually to children that cry unreasonably.

Curses, like chickens, come home to roost.

Cut off his head but mind you don't kill him. A mock injunction to one about to beat a youngster.

Dab, says Dan'l, as he sh . . in the well.

Deeds are Johns, and words Nans. *Worc.* A local version of the proverb — 'Deeds are males, but words females.'

Dillydally brings night as soon as hurryskurry. Mrs. Chamberlain, *West Worcs. Words*, 1882, p. 39.

Don't be always don'ting.

Don't Care was hanged. Said to be a reckless person who exclaims, 'I don't Care!' Some say, 'Don't care came to a bad end.'

Don't drown the miller's eye, i.e. don't put too much water to flour when mixing the dough. 'Millers' eyes' are, in Glouc., the little kernels often met with in indifferent bread. Miss Baker, *Northamps. Gloss.*, 1854, ii. 21, thinks that 'miller's eye' refers 'probably to that part of the machinery which is the aperture in the upper revolving stone, beneath the hopper, through which the corn passes to be ground.' But Ray bears out the former meaning, giving, *To put out the miller's eye*, adding, 'spoken by good housewives when they have wet their meal for paste or bread too much.'

Don't sigh, but send, I'd run a mile for a penny. Said to one that sighs without apparent cause.

Doomsday in the afternoon. A phrase similar in meaning to 'At Latter Lammas' or 'Nevermass;' 'Tib's Eve;' 'Ad Græcas Kalendas;' 'A le venue des coquecigrues,' etc. i.e. Never. See *When the sun, shines, etc.*

Drunk as a boiled owl.

Enough to sicken a snipe. *Glouc.*

Every dog has his day, and a cat has two afternoons. *Warw.*

Every little helps, as the old woman said when she made water in the sea.

Execution Day = Washing day.

Forehanded pay is the worst pay as is.

Fun and fancy; gee up, Nancy. A phrase intimating that a thing is said or done in jest. Some say 'John kiss'd Nancy.'

Gently, John, my daughter's young.

Gloucestershire kindness, giving away what you don't want yourself.

Gold makes a woman penny white.

Half-past kissing time, time to kiss again. A jocular reply to one who asks the time.

Happy as pigs in muck.

He always had a crooked elbow. *Glouc.* 'Said of a man who has been a drunkard from his youth.' — Robertson, *Gloss. co. Glouc.*, 1890. It is often used in Warwickshire, too. 'Crooked elbow' refers to the bent position of the arm in lifting a mug or glass to the mouth. Sometimes the folks say, 'He holds his head back too much.'

He doesn't know where his behind hangs. Said of an insufferably proud man.

He is fit for nothing but to pick up straws, i.e. is a natural, a simpleton.

He lies on his face too much. Said of a man who looks used up owing to frequent observances of Paphian rites.

He makes the bullets and leaves we to shoot them. *Glouc.* Robertson, *Gloss. Glouc.* — 'Said of a person who leaves dirty work to others.' I have never heard it quite in that sense. 'He makes the bullets and you shoot them' is usually spoken of persons acting in concert.

He must have been fed with a shovel. Alluding to one with a wide mouth.

He was born tired = He is thoroughly lazy.

He was born under a threepenny planet, i.e. is avaricious, a curmudgeon. Mrs. Chamberlain, *West Worcs. Words*, 1882, p. 39, quotes Swift's *Polite Convers.* for a different sense, 'If you are born under a threepenny planet you'll never be worth fourpence.'

He would give him the top brick of the chimney. Said of a fond father and spoiled child.

He would not give any one the parings of his nails.

He wouldn't give away the droppings of his nose on a frosty morning.

He would skin a flint for a ha'penny, and spoil a sixpenny knife doing it. These three phrases refer to stingy folk. 'He would flay a flint' is a proverb of remote times. Abdalmalek, one of the Khalifs of the race of Ommiades, was surnamed, by way of sarcasm, Raschal Hegiarah, that is 'the skinner of a flint' *Universal Magazine*, 1796. *He'd take snuff through a rag* is said of a mean, miserly fellow in Worcestershire and the adjoining counties.

He'll never make old bones. Spoken of a sickly child, youth, or young man.

He's a builder's clerk, and carries the books up the ladder, i.e. is a hodman.

He's very clever but he can't pay. *Worc.*

Heads a penny! Said to a child that bumps its head. It is probably an abbreviated form; but the origin is doubtful.

Here goes ding-dong for a dumpling, i.e. neck or nothing. Possibly derived from the old sport of bobbing with the mouth for balm dumplings immersed in hot water.

Here's the cat's mother. *Warw.* Said to one who uses the possessive *her* of the third person instead of the nominative *she*.

His dirt will not stick, i.e. his abuse will harm no one.

His father will never be dead as long as *he* is alive. Said of a son who closely resembles his father in appearance, or ways.

His hair is as straight as a pound of candles.

How are you froggin'? How are you in health? Common in the neighbourhood of Sutton Coldfield, but not unfamiliar in other parts of *Warw.*

How many beans make five? *Warw.; Worc.* (?) Said to test one's sharpness. The 'retort courteous' is not always given. The 'quip modest' is, 'A bean and a half, a bean and a half, half a bean, and a bean and a half.' To say of a man that 'He knows how many beans make five' is to speak highly of his shrewdness.

How you like, and the rest in ha'pence. An answer to some such question as, 'How will you have it?' *it* answering for anything from an unpaid account to a glass of grog.

I am eating my white bread now instead of at the end of my days. Worc.
See Lawson's *Upton-on-Severn Words*, etc., 1884.

I could tell by the whites of his eyes and the bends of his elbows.

I'd as soon hear a rake and basket. Said of discordant singing. 'I'd as zoon
'ear a raëk and basket.' — Robertson, *Gloss. co. Glouc.*, 1890, p. 186.

I shan't undress myself before I go to bed, i.e. shall not give all my property
away whilst alive.

Idle as [H] Ines that was to lazy to get his wagon and horse out of the ditch.
Glouc. This has, perhaps some local tale to back it; but no one seems to
know the telling At first sight it strikes one as an idea borrowed from the
fable of Hercules and the Wagoner, which should run, 'As idle as the hind,
etc.' But this is a chance resemblance, maybe; as *hind*, in country places at
least, is still restricted in meaning.

I'll see your nose above your chin. A mock threat addressed to very young
children.

I'm like Tommy Daddl'em I twet (sweat). *Warw.*

In a jilt of rags. Spoken of a tatterdemalion.

In quick sticks = rapidly.

In the fashion = *Enceinte. See* 'She is so.'

It cost a mint of money. This is the common superlative phrase expressive of
the value of a thing. 'He' or 'she is worth a mint of money' is another form.

It shines like Worcester against Gloucester. Common in the former county.
See Mrs. Chamberlain, *West Worc. Words*, 1882, p. 39.

It tastes of what never was in it. Spoken of a service of food that has a
burnt or smoky flavour.

It's a poor hen that can't scrat for one chick. Chamberlain, *West Worc.
Words*, 1882.

It's all about. Said by one youngster to frighten another, the speaker
thereby pretending that some secret or reprehensible act of his fellow
is commonly talked of. Should *B* be green enough to ask, 'What's all
about?' *A* replies — 'Horse dung!'

It's all for the back and belly, i.e. food and clothing are the main objects of
all endeavour.

It's all moonshine. Said of shallow talk, or an argument not sound, etc.

**It's cold enough to frizzle a yan [hern, heron,] which will stand still in a
pond in the coldest weather.**

It's fun alive.

Village Gossip. "Did ye 'ere as owd Sally Sergeant's dead? 'Er what's bin pew-opener up to Wickleham Church nih on fifty year
The Village Atheist (solemnly). 'Ah! see what comes o' pew-openin'!

It's hats that go to jail, not caps. *Glouc.* Husbands are imprisoned for debt, not wives.

It's like giving a donkey strawberries. To give something too fine or unfit for his condition.

It's neither here nor there. Spoken of an argument unstable and worthless.

I've got a head and so has a pin, i.e. a knob, nothing more. Spoken by one whose wits are cloudy from sleep, etc., when occasion demands a clear brain.

Jack's alive at our house. Said on an occasion of noisy merriment. There is a well-known game at forfeits, in which a lighted spill is passed from hand to hand, the players saying meanwhile —
'Jack's alive, and likely to live,
If he dies in your hand you've a forfeit to give,'
— that may have originated this phrase: for, as the spill burns lower and lower, there is much haste to place it in the hands of the next player, and this is carried on amidst much cheering and laughter.

Jests/Jokes go free till Christmas, and then they begin again.

Johnnies and Mollies. *Worc.* Country lads and lasses. In *Glouc.* applied to place-hunters at the hiring-fair or mops.

Kiss'd, cursed, vexed, or shake hands with a fool. Said by one whose nose itches hoping for the first lot, but prepared for either.

Lay o's for meddlers. Things that children are forbidden to touch. Possibly corrupted from layholds. Another name for a thing forbidden is *Trinamanoose.*

Like a bag of muck tied up ugly. Said of anybody or anything shapeless in form.

Like a chick in wool, i.e. comfortable.

Like a cow's tail (he or she) **grows down hill.**

Like a duck in it stocking, happy anywhere.

Like a frog in a fit. Said of one tipsy.

Like a humble bee in a churn. Spoken of one whose voice is indistinct. *Worc.* 'Like a dumble-dore in a pitcher' is the *Glouc.* Version. Lawson, *Upton on Severn Words and Phrases,* 1884; Robertson, *Gloss. Co. Glouc.,* 1890.

Like a tomtit on a round of beef. A little person is said to look so when situated on some coign of vantage.

Like an Irishman's obligation, all on one side.

Like an old hen scratchin' afore day. *Glouc.* i.e. working at useless time.

Like dogs in dough, i.e, unable to make headway.

Like the old woman's pig, if he's little he's old, i. e. crafty.

Like the old woman's tripe, always ready. *Warw.* In *Worc.* they say, 'Like Dudley tripe,' etc.

Like the tailor, done over. There is an old sung entitled 'The tailor done over.'

Long and narrow, like the boy's granny.

Lucky, John Hodges. Spoken to one who has a find, or experiences a stroke of good fortune.

Making feet for baby's stockings. Spoken of childing woman.

Many/Several men, many minds.

Matrimony. Cake and bread and butter eaten together.

Michaelmas chickens and parsons' daughters never come to good.

More than ever the parson preached about.

My fingers are all thumbs, i.e. have lost their dexterity for a time.

My granny's come back = *Catamenia*.

Neither my eye nor my elbow, i.e. neither one thing nor the other.

Neither sick nor sorry. Said of one who has caused annoyance or trouble and takes the matter lightly. Some understand 'sorry' in the old sense of *sore*.

No carrion will kill a crow. *Glouc.* Robertson, *Gloss.*, 1890, p. 186.

No/None of your tricks upon travellers.

Not worth a tinker's curse.

Old Sarbut told me so. *Warw.* A local version of 'A little bird told me so.' The mythical Sarbut is another *Brookes of Sheffield*, who is credited with the revealing of secrets, and as the originator of malicious statements.

Once bitten, twice shy.

Open your shoulders and let it go down. This is a jesting speech to one about to drink: a jest because to do both is impossible. The antithesis is — 'Drink as if you meant it.'

Out of all ho, i.e, immoderately. This ho is an ancient phrase. word. In John Smyth's remarks on 'Proverbs and Phrases of Speach' we get 'He makes noe hoe of it, i.e. hee cares not for it.'

Out of one's five wits and seven senses.

Out of the road of the coaches, i.e. safe, secure. A housewife might use this phrase when placing a glass in a cupboard, or shutting a child in a room, etc. Another form of the phrase seems to have a more definite meaning. Ray has, 'The coaches won't run over him,' stating that it means 'he is in jail.'

Over the left shoulder, i.e. adverse, contrary to custom. The French seem to claim this phrase, explaining it *du côté ques les Suisses portent la hallebarde — du côté gauche*. It has a figurative position in English: e.g. to do a man a kindness over the left shoulder is to do him an injury.

Paws off, Pompey = Touch me not.

Perhaps it will be like the old woman's dishcloth, look better when it's dry.

Pride must be pinched. A reproof to one who complains of tight boots, garments, etc.

Put a pitch plaster on your mouth = Be silent.

Put in with the bread and pull'd out with the cakes. Spoken of a stupid person: one 'half-baked,' as folk sometimes say.

Rub your sore eye with your elbow, i.e. not at all.

Sam who? *Warw.* A street phrase: a sort of contemptuous 'put off.' *Exs.* 'I'll punch your head;' 'I'll tell your gaffer!' *Ans.* 'Sam who?'

Shake your shirt/ shift and give the crows a feed. Said by way of insult. It implies lousiness.

Shameful leaving is worse than shameful eating.

Sharp work for the eyes, as the boy said when the wheel went over his nose.

She is so. 'Means a female expects to become a mother; probably this delicate phrase was originally accompanied with a position of the hands and arms in front of the person speaking, indicative of a promising amplitude.' The phrase is, however, common in the Midlands, as is 'She is like that,' to which the above remarks may again apply.

She'll make the lads sigh at their suppers. Said of it pretty or attractive girl.

Sh . . . n luck is good luck. Said by one who treads accidentally into excrement, or is befouled by mischance. This superstition, if superstition it be, probally owes its existence to an ancient term for ordure — *gold or gold dust:* and these in turn probably originated from the agricultural value of dung, or perhaps from its natural colour. Mr. Thomas Wright, F.S.A., says — 'The Anglo-Saxon vocabularies have preserved another name *gold hordhus*, a gold treasure house, or gold treasury, which is still more curious from its connexion with the name *gold finder* or *gold farmer*, given as late as the seventeenth century to the cleaners of privies. It is at this time still in use in Shrewsbury to designate such men.' — *Uricornium* (*Wroxeter*), 1872, footnote, p. 146.

Short and sweet, like a donkey's gallop. Some say, 'like a roast maggot.'

Silence in the pigmarket, and let the old sow have a grunt.

Sit on your thumb till more room do come. A reply to a child that continually says, 'Where shall I sit?'

Six of one, and half a dozen of the other. Said of opposite parties in a quarrel, misdemeanour, scheme, etc., when the right or wrong of the matter in question cannot be fixed on either side with certainty.

Slow and steady wins the race.

Sneeze-a-bob, blow the chair bottom out! *Warw.* Said when a person sneezes.

Some day, or never at the farthest. An answer to some such question as, 'When will you bring me a present?'

Sound love is not soon forgotten.

Spare 'em. The limbo of queer or uncouth folk: e.g. 'He comes from Spare 'em.'

Spotted and spangled like Joe Danks's Devil. *Warw.* According to report this Joe Danks was an itinerant showman, who exhibited a wretched creature whose attractions comprised a skin eruption and a spangled suit.

Sticks and stones will break my bones, but names will never hurt me! Said by one youngster to another calling names.

Straight off the reel = without hindrance.

That cock won't fight. Said of an unsatisfactory plan, argument, etc.

That won't hold water. A phrase of similar meaning.

That won't pay the old woman her ninepence. Said of aught not equivalent to given value, in money or kind.

That'll tickle your gig. *Warw.* There seems to be some play on gig, a wanton, and *gig*, slang = pudendum. The phrase is now used of anything likely to cause mirth, or even brisk movement of body.

That's a cock. Said after spitting, should the sl)ittle contain a clot of mucus.

That's a rhyme if you'll take it in time. Said by one who 'drops into poetry' by accident.

That's it if you can dance it. *Glouc.* Equivalent to 'If the cap fits, wear it.'

That's the chap that gnaw'd the cheese/bacon. Points out a person guilty of some offence.

That's the last the cobbler threw at his wife. Said to end an argument. The play is on 'last.' Actually, the *last* word is meant.

That's the stuff for trousers. This phrase, which once bad a definite meaning, no doubt, is now freely used of any good thing.

That's what you are! i.e. a snot. A street phrase, and deadly insult. The insulter blows his nose, and then says the say. The insulted one sometimes says 'There's two friends parted.'

The best of the boiling/bunch. Spoken of the worthy member of some family or company.

The bigger the man, the better the mark, i.e. to aim, or strike at in combat.

The colour of the devil's nutting bag. Said of anything dingy or bad-coloured.

The devil hung in chains. *Warw.* A cooking turkey dressed with sausages.

MORE AMALGAMATION. - *Parish Councillor.* "Wull, I do voate that the two par'shes be marmaladed." Chairman. "Our worthy brother councillor means, I understand, that the two parishes should be jammed together!"

The devil knows many things because he is old.

The dustman/sandman's come into your eyes, i.e. you are sleepy; usually addressed to children.

The ghost of Old Flam. *Warw.* Any mysterious noise is said to be caused by this spectre.

The more hazelnuts the more bastard children. *Glouc.*

The smock is nearer than the petticoat.

The tops of the potatoes [etc.] have the soot bag over them, i.e. have been blackened by the frost.

The very devil chock! i.e. chokefull of the devil.

The way Gandy hops. Expressive of the tendency of ones wishes or deeds.

The Welsh ambassador = The cuckoo.

The Wooden Hill. The stair. 'To go up the wooden hill' = to go to bed.

There are more houses/parsons than parish churches.

There were only two that came over in the same boat with him, and one is dead.

There's more old [ale] in you than fourpenny. Said to a sharp-witted person. Fourpenny is beer at 4*d*. per quart.

There's no profit got from feeding pigs but their muck and their company.

There's nothing done without trouble, except letting the fire out.

Thirteen pence out of a shilling.

Through the wood, and through the wood, and pick up a crooked stick at last.

Throw your orts/rubbish where you throw your love. This is admonitory, not a piece of advice: some add 'and in bigger pieces!'

'Tis a blessed heat, tho', as the old woman said when her house was on fire.

To be a cup too low.

To be born with no gizzard, i.e. with a poor digestion.

To be brother and Bob, i.e. hand and glove.

To be down in the mouth.

To be down on one's duff. *Warw.* i.e. down on one's luck; or in the dumps.

To be fall of good keep.

To be measured for a new suit of clothes = To have a thrashing.

To be off the hinges = To be out of temper, or in bad spirits.

To be on the wrong side of the hedge = To be badly situated in any circumstance.

To be put to one's trumps = To be embarrassed.

To be sick of the simples, i.e silly. In *Warw.* they say to the performer of a foolish action, 'I'll have you cut for the simples.'

To be struck all of a heap = To be surprised.

To be the very spawn of a person. *Worc.*; *Glouc.* i.e. exactly like. Some say 'the very spit:' e.g. 'He looks as like his father as if he was spit out of his mouth.'

To be up in the boughs = To be out of temper. *Worc.*; *Glouc.* Lawson, *Upton-on-Severn Words*, etc., 1884.

To be whitewashed = To pass through the bankruptcy court.

To blow one up skyhigh = To rate soundly.

To box Harry and chew rag, i.e. to go on short commons. In North Britain should one say, 'What's for dinner?'—when there is some uncertainty from want or other cause the answer would be *Cat's teeth and clinkins*. In *Glouc.* the reply is, 'Barley-chaff dumplings sugared with wool.'

To break a man's back = To ruin him.

To catch the chat = To receive a reprimand.

To clear one's feathers = To got out of debt, rub off old scores, etc.

To come back/turn up like a bad half-penny.

To come off with a whole skin.

To come off with flying colours.

To crock up = To store.

To cry roast meat. (1) to make known one's good luck. (2) to boast of women's favours.

To dispute with Bellarmin = To quarrel with the bottle. The Bellarmin—a dutch mug or jug—is a varied form of our Toby Tosspot, Greybeard, etc.: but the face upon it was popularly likened to the visage of Cardinal Bellarmin, the bitter opponent of the reform party in the Netherlands, in the latter part of the sixteenth and early part of the seventeenth centuries.

To draw in one's horns = To lose, ground in argument.

To draw the long bow = To exaggerate, to lie.

To draw the yoke together = To work in concert.

To drink like a fish.

To drink like an ass, i.e. when thirsty only.

To eat enough for three bears.

To fall into the huckster's hands = To be cheated, duped.

To feel all overish.

To fetch copper = To strike fire from stone with iron. Youngsters of *Warw.* run swiftly along the paved side-walks striking sparks therefrom with their nailed shoes, and use the phrase.

To fix the bottom on one = To become a parasite.

To fly one's kite. Brewer, *Dict. Phrase and Fable*, says, *To fly the kite* is 'to raise the wind, or obtain money on bills, whether good or bad. It is a Stock Exchange phrase, etc.' In *Warw.* A very different meaning is understood, i.e. 'to shake a loose leg,' or enjoy one's-self.

To follow one's ear = To go out of one's way to discover the source of a distant noise.

To fret the guts to fiddle-strings.

To get behind the wicket.

To get more kicks than ha'pence.

To get on the blind side of any one.

To get the forehorse by the head = To get out of debt: to see one's way clear, etc.

To get used to a thing like an eel to skinning.

To give one Bell Tinker! = To beat, as tinkers clout a pot.

To give one the bag to hold = To cozen, cheat, etc.

To go away with the breech in the hand = To retire chapfallen. 'Breech' is substituted for the more vulgar word, Sometimes it is said of a man who 'gets the wrong end of the stick' in a matter that 'He goes off hopper-a . . . d.'

To go home with the parish lantern. *Worc.* i.e. the moon.

To go off like one o'clock, i.e. 'with as little delay as a workman gets off to dinner when the clock strikes one.'—*Lectures on the Science of Language*, by Prof. Max Müller, M.A., 1885, i. 69.

To go scratching on.

To have a dog in one's belly = To be ill-tempered.

To have a fling at a man = To make him a mark for abuse. The phrase 'To have one's fling,' i.e. to indulge in one's liberty, has no bearing on it.

To have a grumbling in the gizzard = To be ill-content.

To have a screw loose = To be out of sorts, etc. It is also used of a demented person.

To have been priming up, i, e, drinking.

To have but one eye, and squint of that.

To have dropped a watch in the bottom of a rick. *Worc.* 'A jocular hypothesis,' says Lawton, *Upton-on-Severn Words*, etc., 'to account for the cutting or turning of a rick which has become overheated.'

To kick up Bob's a-dying = To make noisy merriment.

To leather one's pig = To drub, actually, or in argument.

To look as if one had been drawn through a hedge backwards.

To look like a boil'd turnip, i.e. sickly. In *Worc.* one may hear, 'He looks as if he'd been eaten and spew'd up again.' In *Warw.* they say, 'You look as if you bad murdered a turnip and washed your face in its blood.'

To look like a dog that has burn'd his tail, i.e. ashamed, discomposed. Ray has, '*lost* his tail.'

To look two ways for Sunday. Said of the improvident.

To make a maygame of one = To mock, rail, etc.

To make brick walls = To swallow without chewing: to eat greedily.

To make one dance without a fiddle = To give a drubbing.

To make the neddy, i.e. a fortune, or large profit.

To-morrow goes by of itself.

IMPARTIAL

New Curate (who wishes to know all about his parishioners). "Then do I understand you that your aunt is on your father's side, or your mother's?"
Country Lad. "Zometimes one an' zometimes the other. 'ceptin' when feyther whacks 'em both, sir!"

To part with dry lips, i.e. without drinking.

To pick up a knife = To have a bad fall in riding.

To play sure play, i.e. with all the points in one's keeping.

To play the bear with one = To harass, to vex. In *Glouc.* 'To play the very Buggan with one.' Huntley has the latter phrase. Buggan = Old Bogey, Satan, or any evil spirit.

To pop about like a parched pea on a shovel. 'Like a pea on a drumhead' is another version.

To pour water on a drowned mouse = To cast out spite on one past vengeance.

To preach over one's liquor = To crack up its excellence as an excuse for drinking.

To put down one's dripping pan = To pout the under lip.

To put one's spoon into the wall = To die. *Worc. & Glouc.*

To put two and two together = To establish truth by reasoning.

To quarrel like fighting cocks.

To ride a free horse to death = To abuse one's patience or kindness.

To ride rusty.

To set the dice upon one = To cheat, to gull. *Vulg.*

To sleep like a pig.

To spite one's belly for the sake of one's back, i.e. to stint one's self of food to provide fine clothes.

To spite one's nose for the sake of one's face, i.e. for the *offence* of one's face. Another form is 'Don't cut off your nose to spite your face.'

To stand to one's pan-pudding = To be firm: to hold to a position.

To stare like a throttled Isaac.

To stick up one's stick = To die. *Worc.*

To stink like a herring.

To swear like a trooper.

To take tea in the kitchen = To pour tea from the cup into the saucer, and drink it from this.

To take to one's heels = To retreat.

To take up the cudgels for any one = To fight another's battles.

To talk the leg off an iron pot = To chatter incessantly. It is sometimes said of a talkative person that he or she 'would talk a horse's [or donkey's] hind leg off.'

To tan the hide = To chastise.

To throw a thing in one's teeth/dish = To reproach.

To throw cold water on a thing = To decry.

To trim one's jacket = To thrash.

To tumble to pieces = To give birth to a child. This repulsive, and, one might add, irrelevant phrase is common.

To turn up the eyes like a duck at thunder. An inferior, or corrupted version is, 'like a dying duck in a thunderstorm.'

To walk an Alderman's pace, i.e. sedately, with gravity.

To walk like a cat in pattens, i.e. in a pottering way.

To walk like a cat on hot bricks, i.e. in a jerky fashion.

To warm the cockles of one's heart = To enjoy to the very core.

To watch one's waters = To keep an eye on a person; to follow his movements.

To wear the yellow = To be jealous. 'To wear the Yellow' meant, among old authors, to be free, one's own master, or a bachelor, e.g. 'Give me my yellow hose again.'—Old song.

To wipe a person's eye, i.e. see what he does not see.

To work like a thresher.

To work upon the raw.

To-morrow's the day that never came yet, but the name of the day comes every week.

Too big for his boots. Said of one, overbearing, or supercilous in manner.

Too thick to thrive. Said of live stock too abundant in a place.

Top bird of the basket.

Touch and go.

Trying to look as modest as an old w . . . e at a christening. *Glouc.* Said of a woman who affects a chaste manner on occasion.

Two heads are better than one, even if the one's a sheep's. An extended version of the well-known and ancient proverb. 'A sheep's' head, in folk figure, means a daft or unreasoning head. There seems to be a country joke on *two heads*, which has several forms. Mr. Hazlitt, *Proverbs*, 1882, has, 'Two heads are better than one, quoth the woman, when she took her dog with her to the market.'

Two swedes to a ton of mutton. *Warw.* A formula used by one who does not wish to gamble for high stakes. 'I'll bet you a button' belongs to the same class of saying.

Two-year breeders never ha' done. *Warw.* Said of married people whose first children are born one child two years after the other.

Up a daisy! Addressed to a child when taking it up into the arms; or in lifting it from the ground after a, fall.

Wash together, wipe together, fall out and fight together.

We shall live till we die, like Tantarabobas.

Doctor. "Well, Mrs. Muggeridge, how are you getting on? Taken the medicine, eh?" *Mrs. M.* "Yes, doctor. I've taken all the tabloids you sent, and now I want a new persocution."

Weeds don't spoil.

What's a cat but its skin?

What's a penny made of? This is a street jibe uttered in the hearing of a policeman. The answer is 'Copper!' *Copper*, from the slang verb *to cop*, i.e., to catch, signifies constable.

What's the good of a well without a bucket? 'Well' is an exclamation of surprise, greeting, inquiry, etc. It is often, too, a palliative, or the introduction to an excuse, or poor argument. The phrase given is said in reply to these last usages. To the former, the jesting answer is, 'That's what David said to Nell.'

When the monkey jumps = When inclination prompts.

When the sun shines on both sides of the hedge, i.e. never. Frequently said to children that inquire when their parents will take them for an outing, or bring presents. Mr. Denham has, 'The sun shines on both sides of the hedge,' and states that it signifies the position of that body at meridian. I venture to assert, however, that the former is the better reading.

Who stole the donkey? Shouted after the wearer of a white felt hat. The idea seems to be that the hide of the animal was used to make the hat.

Who stole the donkey's dinner? Answer. '*Him* with the straw brimmer.' Even in Canada a straw hat is called 'the donkey's breakfast.'

Winking and blinking like a rat in a sinkhole.

With a whiz, i.e. Giddily.

With half an eye. Usually spoken of 'the mind's eye:' as, 'A man may see it [the point of the matter in question] With half an eye.'

Worcester, poor, proud, and pretty. Mrs. Chamberlain, *West Worc. Words*, 1882, p. 39, says of this well-known phrase, 'It is proverbial that the Worcester ladies are poor, proud, and pretty. That the accusation of pride may be brought against the Worcester people generally is proved by their saying that 'Ours is the only county that can produce everything necessary for its own consumption.'

Worse and worse, like Povey's foot. Robertson, *Gloss. Glouc.*, 1890. Povey = an owl. The phrase is used in other counties. Hartshorne, *Salopia Antiqua*, 1841, thought that some man named Povey had a swollen foot which became proverbial. He preserves the Shropshire variant, 'as large as Povey's foot.'

You are come like snow in harvest, i.e. unexpectedly. A person wearing a sour expression is said to look 'as pleasant as snow in harvest.' Ray includes a version amongst 'Scotch proverbs.' It is, however, common in the Midlands.

You be like Jimmy Broadstock's turkeycock, stand and sit. 'Sit 'e down, Gearge! 'No, I be a gwain while I be a standin'! 'O you be like,' etc. This Broadstock, folks say, was a farmer near Cheltenham, and he owned a ridiculous he-bird that used to stand astride over the eggs—thinking, no doubt, to help to hatch—when the hen left her nest for food.

You have done it in a dish, i.e. cleverly.

You mean pudding and I mean pork, i.e. we talk of different matters. It seems to be a form of the old proverb—'I talk of chalk and you of cheese.'—Dyke's *English Proverbs*, 1709, p. 54. Ray gives an Italian phrase of the same kind, 'Io ti domando danari e tu mi rispondi coppe.' In the Midlands, when one wanders in argument, another replies, 'What's that to do with pork?'

You might as well rub your backside with a brickbat. Said of an action that would cause unnecessary hardship or infliction.

You might put/feel it in your eye and see none the worse. Spoken of a small portion of anything.

You must not expect perfumes in a pigsty. In Herbert's *Outlandish Proverbs*, 1640, we get, 'Look not for musk in a dog's kennel.'

You should not think till the crows build in your bum and then you should wonder how they got the sticks there. Said to one who apologises for an error by the remark, 'I thought "so and so."'

You were not behind the door when the eyes/noses were given out. Said to one specially favoured in some feature.

You'll be well before you're twice married. Said to someone who complains of a trifling ailment. 'You'll be worse before you're any better' is said by one woman to another in labour pains.

You'll pass in a crowd with a good push. An answer to one who says, 'How do I look?'—in the way of dress, etc.

You're a nice young man for a small tea party. Ironical.

VOCABULARY.

Those words are not in the printed glossaries, nor in Halliwell's *Dictionary of Archaic and Provincial Words*, 2 volumes, 1878; Wright's *Dictionary of Obsolete and Provincial English*, etc.

Applefoot = Apple turnover. *Glouc.*

Attwood = A silly fellow. *Warw.*

Ayzam jayzam = Equitable; fair and square. 'Upright down straight' is an old term for the same meaning.

Backfriend = A small piece of loose skin near the base of the finger nail. *Warw.*

Bancel, *v. a.* = To beat out, to drive. *Glouc.*

Bob-a-lantern = A turnip lantern. *Warw.*

Bob 'owler or **Bob bowler** = The tiger moth. *Warw.*

Farmer's Wife (whose beer is the smallest). "Why, you hevn't drunk half of it, Mas'r Gearge!"
Peasant (politely). "Thanky' mu'm-all the same, mu'm. But I bean't so thusty as I thought I wor, mu'm!!

Bodge, *v. a.* = To prod or pierce with an instrument.
Bread and cheese = The leaves and young shoots of hawthorn hedges. *Warw.*
 and *Glouc.*
Bug = A clot of mucus from the nose. *Warw.*
Bullyhead = A tadpole. *Warw.*
Butter-my-eye = A butterfly. *Warw.*

Caggy or **Keggy** = Lefthanded.
Chabble or **Chobble,** *v. a.* = To chew. *Glouc.*
Chatterwater = Tea. *Modern.*
Chelp, *v. a.* = To talk overmuch. *Chelping* is replying or chattering to

one's elders, without respect.

Chucky pig = A young pig.

Chuff = Bread; sometimes, but not often, used broadly for food. *Warw.*

Clozam, *v. a.* = To appropriate. *Warw.*

Codge, *v. a.* = To cobble, or mend clumsily. *Warw.* See 'Modge.'

Corkle = The core of fruit.

Cowge, *v. a.* = To pilfer, to steal forcibly. *Warw.* See 'Rant.'

Cows and calves. Children sometimes rub their moist hands, after play, and work up little rolls of dirt-charged moisture. These they term 'cows and calves.' *Glouc.*

Crap, *v. n.* = To discharge excrement.

Cunnythumb. To shoot with a *cunnythumb* is to discharge a marble with the thumb released from far beneath the fore-finger. *Warw.; Worc.*

Daddies and Mammies = The dust-charged collections of moisture that gather between the toes after a walk, etc. *Glouc.*

Devil's oatmeal = Cowparsnip (?). *Warw.*

Dirty Dan'l [Daniel] = Treacle.

Docker me! *excl.,* e.g. 'Docker me if I do!'

Dogger = A mallet or bat, comprising a handle fitted to a heavy cylindrical end, used in a game differing from *knur and spell* in that a one-nosed tipcat is used instead of a hall. *Warw.*

Donkey = A four-square block on which marbles are placed to be shot at. The term is also applied to a board pierced at intervals, each hole having a number above it, at which marbles are discharged in the hope of their passing through some hole of high value. The numbers represent the marbles that the holder of the donkey must pay if the shooter be successful. The shooter loses his marbles that strike the donkey without passing through a hole. *Warw.*

Dummox = Clay marbles of inferior quality, 'pots.' *Warw.*

Dummy = A candle. *Warw.*

Dunnekin or **Donnykin** = A privy, jakes. *Warw.*

Durgey = A dwarf. Also an adjective, e. g. 'A *durgey* little man.' In other counties, according to Halliwel, *durgan.* (*Ang. Sax.* Dveorg, a dwarf: *Goth.* Duergar, dwarfs.)

'E-stich-'em-stich = Hasty pudding.[1] *Glouc.*

Faggot = A small savoury pudding of liver, lights, etc., chopped small. *Warw.*

Footstich = A footstep.

Frum = Concupiscent,[2] big with desire. This is the exact *Warw.* meaning. It has other meanings in other counties.

Fudge, *v. n.* = To advance the hand unfairly when discharging a marble.

Gaubshite =A filthy boor. 'A jolter-yeded (headed) gaubshite' is an insulting phrase in *Warw*. But see Northall's *English Folk Rhymes*, p. 304 'Gobbinshire, Gobbinshire,' etc.

Glozzer = A perfect cast or throw of a spinning top.

Hatredans = Ill tempers, 'Tantrums.' *Glouc.*

Haunty = Uneasy with desire. It is equal to the Scotch 'fidgin-fain.'

Hill, *v. a.* = To tuck or round a child up in bed. (*Hill*, v.a. to cover, is a good old English word. Mr. Halliwell quotes *MS. Lincoln*. A. i. 17f. 134 as an example.) But a child may be covered and yet not *hilled* up. It is generally the last thing a woman does before she leaves the bedroom of a child. *Hilling* or *heeling*, the round back of a book, seems to he formed from this verb. *Warw.*

Hodge = The belly, e.g. 'To stuff one's hodge.' *Warw.*

Holy-falls = Trousers buttoned breeches fashion, having the flap, not the fly front.

Howk or **yowk**, *v. n.* = To howl.

Inchy-pinchy = Progressive leap-frog. *Warw.*

Itching-berries = The berries of the dogrose. They contain woolly, prickly seeds, and these, the children put down their playmates' backs.

Jackbannel or **Bannock** = The minnow. *Warw*. Halliwell has 'Jack Barrel,' but this is never heard. In his edition of Sharp's *Warw. Gloss.* he has 'Jackbannel,' however. But bannock is more usual.

Jank = Excrement. *Jankhole* = privy, jakes, midden, miskin. *Warw.*

Jibber and jumbles = Sweetmeats.

Joey = The green linnet. *Warw.*

Jole, *v. a.* = To knock or bump another's head against an obstacle.

Kit = A flock of pigeons. *Warw.*

Knurley or **knuz** = (1) The ball of hard wood used in the game of shindy or bandy. (2) *adj.* e. g. 'A knurley little man' = one hard, compact, sturdy of make.

Maid = A wooden beetle used to pound clothes in the washing, or maiding-tub, a dolly. *Warw.*

Mecklekeckle = Poor in quality, or fibre: e. g. 'A mecklekeckle sort of fellow.'
Mr. Halliwell states that kecklemeckle, *sub.* is the Derbyshire miner's term for poor ore. *Glouc.*

Miller's dogs = Caterpillars. *Glouc.* See 'Woolly-bear.'

Modge, *v. a.* = To work badly. Frequently used with *codge*, e.g. 'Don't codge

and modge at that patch any longer.' *Warw.*

Morris! *imper.* = Be off. *Warw. Worc.*

Munch, *v. a.* = To maltreat. The substantive is the same, e.g. 'She is a cruel munch to her children.' *Warw.*

Nammus! *imper.* = Be off. *Warw.* etc.

Nick-and-brick = A variation of chuck-farthing, the dividing line between two bricks in a pavement affording the mark.

Nineter = An artful youngster. *Warw.* Halliwell has *nineted*, wicked, perverse.

Nogman = A numskull. *Glouc.*

Ockerdocker = A greasy-looking black pebble, striped with some other colour, regarded as a lucky stone. I do not think the word is of old standing in *Warw.* It probably belongs much further north.

Padgell, *v. n.* To trifle; *adj.* padgelling, e.g. 'a padgelling way of paying a debt;' i.e. little by little. *Warw.*

Peff = Punishment. 'To give a man peff' is to thrash him. *Warw.*

Pell, *v. a.* = To bare, e.g. 'Don't pell your hair back so.' *Glouc.*

Pewey = The pea-linnet. *Warw.*

Pithering, *a.* = Trifling. *Warw.* Halliwell has *pither*, to dig lightly, to throw up earth very gently. *Kent.*

Podge, *v. a.* = To give a blow with the fist, to punch. *Warw.*

Poke or powk = A stye. *Warw.* This is the Shropshire meaning, too, according to Hartshorne. In other, counties it seems to be used for any pimple.

Pollydoddle = A man who potters about at woman's work; a mollycoddle.

Polt, *v. a.* = To beat or knock. *Glouc.*

Pup, *v. a.* = To crepitate from the anus. *Warw.*

Rant, *v. a.* = To steal by force. Boys use this term to signify forcible appropriation of marbles or other toys. It is also used of forcible and undue familiarities with females. *Warw.*

Rodney = A helper on canal paths; the one that opens the locks.

Roozles = Wretchedness of mind; the miserables.

Say, *v. n.* = To micturite. Wright, *Dict. Obsolete and Provincial English*, has '*say*,' to strain thro' a sieve. *Leic.*

Scouse, *v. a.* = harry, to drive. *Glouc.*

Scruff = A worthless fellow, a wastrel. *Warw.*

Scrumps = Apples. *Warw.*

Seven-coloured linnet = Goldfinch.

Shining = Stealing—particularly apple stealing. *Warw.*

Sigh, *v. n.* To waste, to fade, as 'the sighing away of a boil,' etc.

Skrinsh = The smallest possible portion of anything.

Sogs = Gooseberries. 'Goozgogs' is another common term. *Warw.*; *Glouc.*

Soysed, I'll be. *Exclam.*

Sprightle up, *imper.* = Be brisk, lively (sprightly). *Warw.*

Squilch = A 'blind' boil. *Glouc.*

Squit = Nonsense. *Warw.*

Stitchwhile = A moment. Generally used in conjunction with every, as, 'every stitchwhile.' *Glouc.*

Strommock, *v. n.* = To walk ungainly.

Taw = The mark from which players start for a race, jump, cast stones, etc. 'Take off taw,' i.e. leap or start from the line.

Thunderball = The poppy. *Warw.* Many glossaries have 'thunderbolt.' It is believed by children that to pluck it will draw down the 'bolts of heaven' on them. Venus and Jove—or possibly Venus and Vulcan—seem to be in conjunction here.

Tittymog = A child frequently at the breast. 'Mog,' or 'Moggy,' is, in several counties, a term applied to a calf. Another term for a suckling is 'lugtit.'

Trollymog, *v. n.* = To walk about heavily and aimlessly. 'Don't let's go trollymogging about any more.' *Lichfield.* In Worcestershire they say

Giles. "I be got up here, mister, but I don't zee 'ow ever I be goin' to get down."
Farmer. "The zhut thee eyes an' walk about a bit, an' thee'll zoon get down!"

'loblolling.'

Wingell, *v. n.* = To murmur or whimper incessantly. Hartshorne has it in his *Salopia.*

Woolly-bear = A caterpillar. *Warw.* In other parts of the country, caterpillars are called 'Cats and kittens.'

Wrile or **rile,** *v. n.* = To fidget on another's lap, or to got tip and down on another's knees. It may be a corruption of wriggle.

Hasty pudding: a pudding or porridge grain cooked in milk or water.

Concupiscent: lustful or sensual, eagerly desirous.